STIRLING
THROUGH TIME
Jack Gillon

AMBERLEY

First published 2016

Amberley Publishing
The Hill, Stroud, Gloucestershire, GL5 4EP
www.amberley-books.com

Copyright © Jack Gillon, 2016

The right of Jack Gillon to be identified as the Author
of this work has been asserted in accordance with the
Copyrights, Designs and Patents Act 1988.

ISBN 978 1 4456 5795 0 (print)
ISBN 978 1 4456 5796 7 (ebook)

British Library Cataloguing in Publication Data.
A catalogue record for this book is available from the
British Library.

Typesetting by Amberley Publishing.
Printed in Great Britain.

Acknowledgements

Stirling may be the smallest of Scotland's seven cities, but it has a fascinating wealth of architectural and historic heritage which would be the envy of much larger places in the country.

I have enjoyed many visits to Stirling over the years, and it was a pleasure to be able to spend more time in the city and delve into its enthralling history.

Special thanks go to Norma Gillon for transport and lots of laughs. Also thanks, as ever, to Emma for her patience and support.

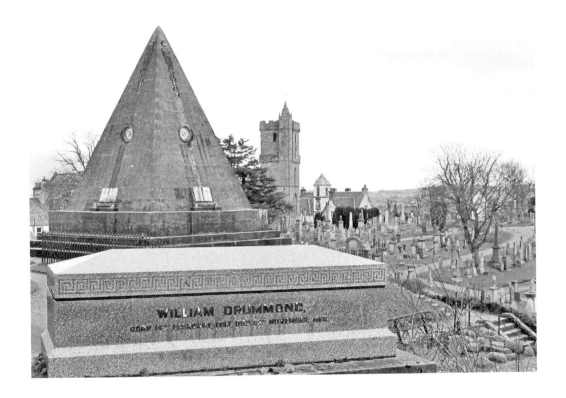

Introduction

'Stirling, like a huge brooch, clasps the Highlands and Lowlands together.'

Alexander Smith, *A Summer in Skye* (1865)

Who, does not know Stirling's noble rock, rising, the monarch of the landscape, its majestic and picturesque towers, its splendid plain, its amphitheatre of mountain, and the windings of its marvellous river; and who that has once seen the sun descending here in all the blaze of its beauty beyond the purple hills of the west can ever forget the plain of Stirling, the endless charm of this wonderful scene, the wealth, the splendour, the variety, the majesty of all which here lies between earth and heaven.

John Macculloch, *The Highlands and Western Isles of Scotland*, (1824)

Geography was a critical factor in Stirling's development. Spanning the boundary between the Highlands and Lowlands and standing at the heart of Scotland, it developed as a fortress town at the lowest bridging point over the River Forth, which was a vitally strategic crossroads and the location of the rugged volcanic crag of the Castle Rock.

Stirling's strategic importance as the 'Gateway to the Highlands' also made it the much fought over 'Cockpit of Scotland' and it has been witness to many of the most significant battles in Scottish history – the Battle of Stirling Bridge (1297), Bannockburn (1314), Sauchieburn (1488) and Sheriffmuir (1715). It was said that to take Stirling was to hold Scotland. Therefore, it comes as no surprise that the name Stirling is derived from 'Striveling', which means place of strife.

The town developed on the steep tail that runs down from the castle's rocky crag and early settlement prospered under the protection of the castle. It was one of the four principal royal burghs of Scotland, with a charter that dates from 1226 and a burgh seal from 1296. It was the market place for Stirlingshire and much of the rest of the country and also a port since medieval times.

During the thirteenth and fourteenth centuries, the castle and town were razed during the Wars of Independence between England and Scotland; defensive walls were built around the town in 1547. During the fifteenth and sixteenth centuries, the Stuart kings made Stirling their favoured residence and the arrival of the royal court did much to foster the development of the town.

With the exception of the tradition of weaving, much of the Industrial Revolution bypassed Stirling, which contributes to its enduring character. Stirling principally functioned as a market town servicing the surrounding rich agricultural carse lands of the River Forth.

Stirling was also a historic port which supported overseas trade and had a daily steamer service to and from Leith. The advent of the railway in 1848 started the decline of the river trade and by the mid-twentieth century, the port had ceased to operate. At the time of writing, there are exciting proposals to put the river back at the heart of the city. These include the Forthside development, which has already regenerated part of the riverbank; a river taxi network, with stops connecting key sites; and enhanced riverside walking and cycle paths, linking the river with the city centre.

Stirling is central to Scotland and its history, and today it is a charming historic city that retains much of its ancient character and architectural quality. Stirling was granted city status as part of the queen's Golden Jubilee celebrations on 12 March 2002.

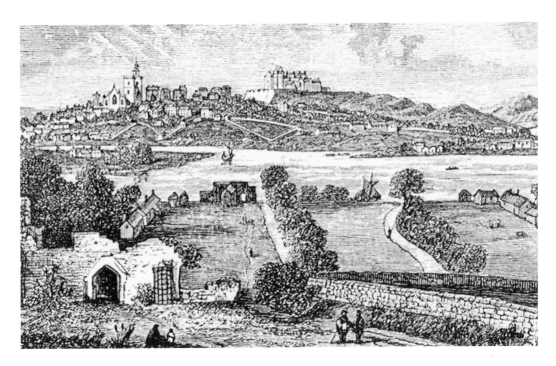

Stirling from Cambuskenneth

The older view of Stirling is a detail from a print that dates from 1693. It shows the castle, with the town and the Church of the Holy Rude to the left. The ruins of Cambuskenneth Abbey are in the foreground, surrounded by a rural scene.

Stirling still remains within a rural setting in the recent image and its historic profile is still recognisable.

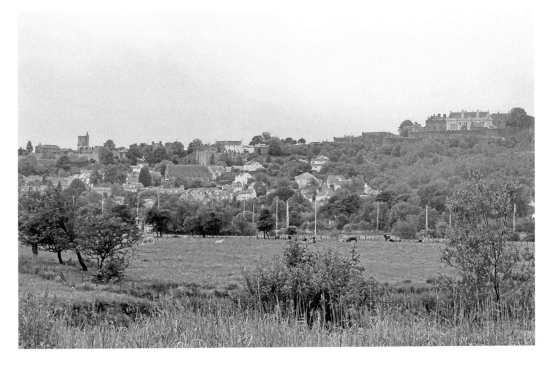

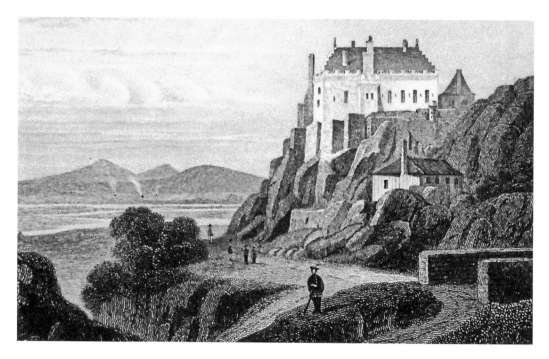

Stirling Castle

Set dramatically on its high crag, Stirling Castle dominates the landscape for miles around. Although there is no clear evidence, it is likely that its naturally defensive site was a stronghold from prehistoric times. The earliest reference to the castle is in the early twelfth century, when Alexander I endowed a chapel within it.

The castle changed hands repeatedly in the wars between Scotland and England.

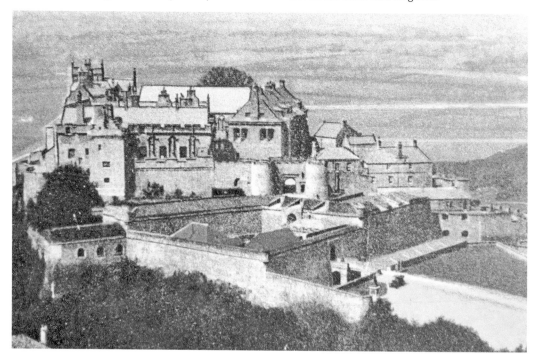

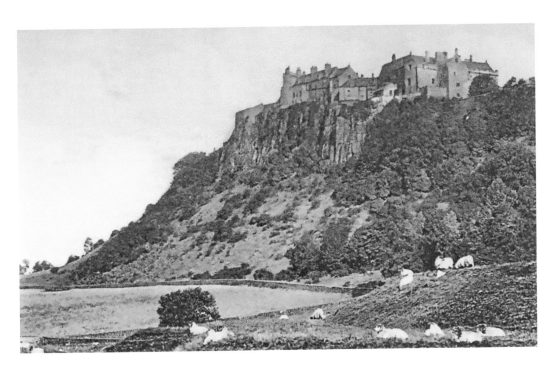

Stirling Castle

Much of the castle buildings date from the late fifteenth to sixteenth centuries when it was a fortress, royal palace and a favourite residence of the Stuart kings. After the Union of the Crowns in 1603, the Stuarts effectively abandoned the castle as a residence. It was in use as a military base from the late seventeenth century and additional defences were built in 1708 due to the unrest caused by the Jacobite threat. The national importance of Stirling Castle and potential for tourism were recognised in the 1960s and a programme of restoration works undertaken. The castle is now one of the most visited tourist sites in Scotland.

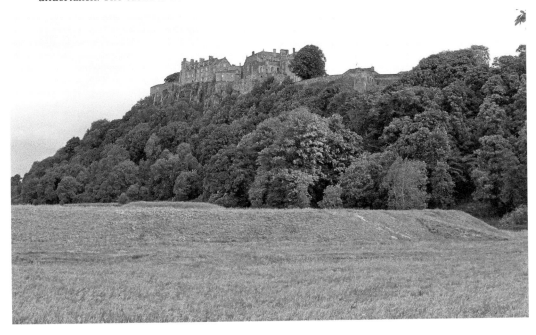

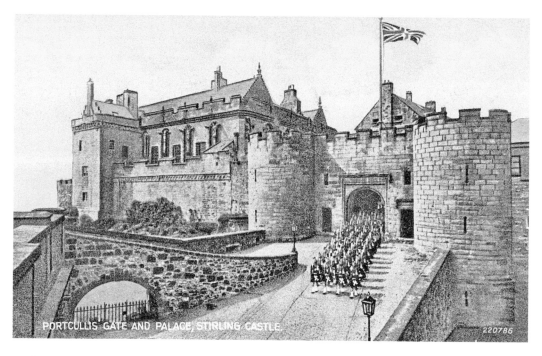

PORTCULLIS GATE AND PALACE, STIRLING CASTLE. 220786

Stirling Castle, Forework

The castle is well defended on three sides by steeply sloping rock faces. The approach from the south was more of a soft target and was the most fortified. The present forework dates from around 1506 and was built under the reign of James IV. It originally consisted of six towers with conical roofs which, along with the guardhouse, were twice as high as at present.

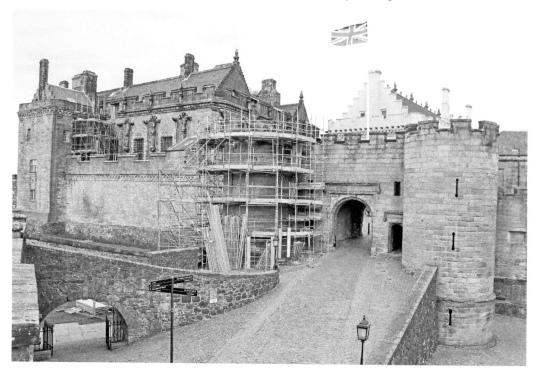

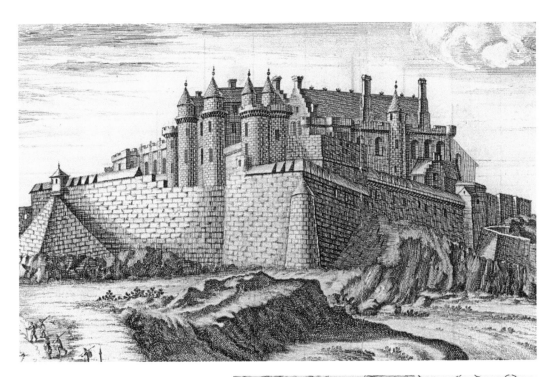

Castle Forework and John Damian

The original height of the forework can be seen in the above image of the castle.

John Damian de Falcuis was an Italian at James IV's court. He was employed as an alchemist and was known as a great favourite of the king. He is best known for his attempt to fly from Stirling to France in 1507. A large crowd gathered to witness the aeronautical feat and at the appointed time Damian, wearing an enormous pair of wings, launched himself from the battlements of the castle. Inevitably, he plummeted to the ground and was fortunate to only break his leg. He later reasoned that his failure was due to the eagle feathers in the wings being contaminated with poultry feathers. However, there is no record of him attempting further flights.

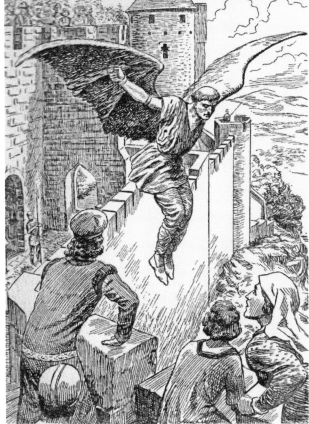

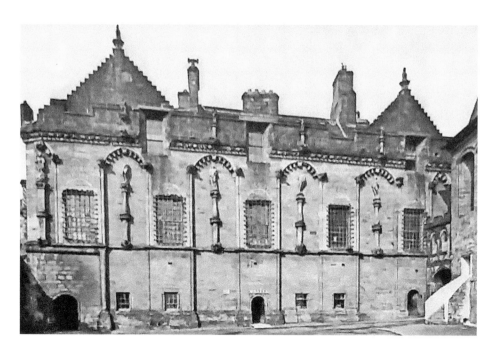

Castle, Royal Palace

The royal palace at Stirling Castle was built during the latter part of James V's reign as appropriately prestigious accommodation for the king and his queen, Mary de Guise. Work started in the 1530s and it was mainly completed at the time of James' death in December 1542. The interior originally consisted of an almost symmetrical arrangement of a matched group of rooms of state: a public outer hall where nobles and courtiers met the monarch, an inner hall for more exclusive audiences and an inner bedchamber for the most privileged inner circle of advisers. Daniel Defoe described them as 'The noblest I ever saw in Europe, both in Height, Length and Breadth'. The rooms were grouped around a paved courtyard known as the 'Lion's Den' – from the heraldic lion of Scotland or possibly from the fact that it housed a real lion. The palace was the childhood home of the young Mary Queen of Scots.

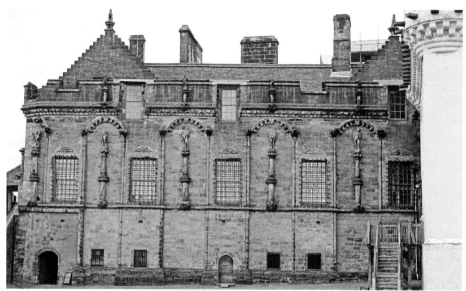

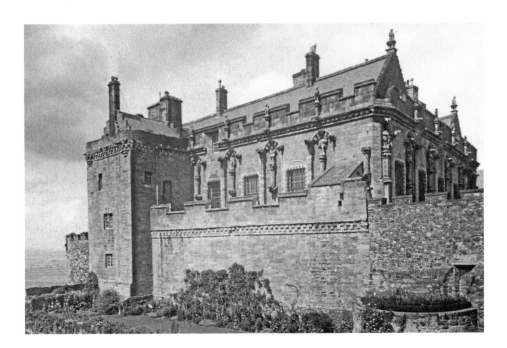

Castle, Royal Palace

The palace continued in use as an important royal residence until the Union of the Crowns in 1603, when the court moved to London and the building lost its main purpose. It was gradually converted for military accommodation in the eighteenth century. After the departure of the army in 1964, the building served as a function room and café. In June 2011, the building opened to the public after a £12 million project to recreate its original splendour. This included replicas of a series of beautifully carved oak portrait roundels, known as the Stirling Heads, which were originally installed on the ceiling of the king's Presence Chamber. The original heads had been taken down in 1777, as they had become insecure.

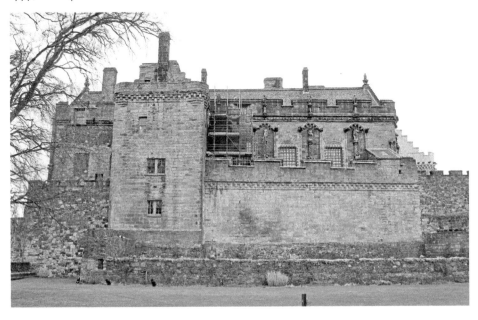

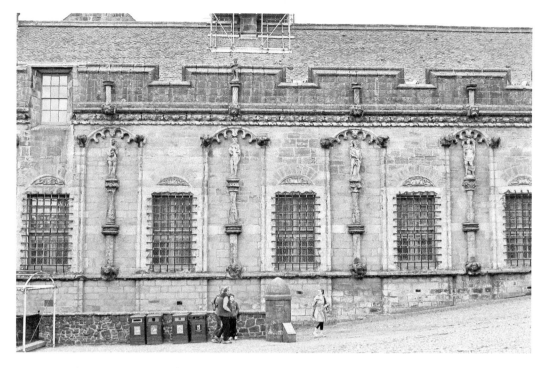

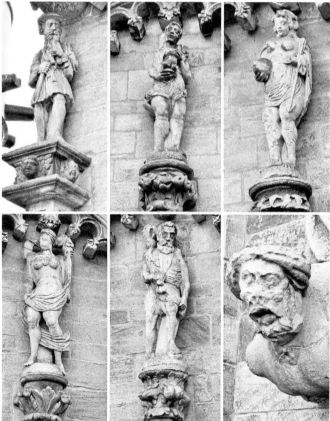

Royal Palace Statues

The exterior of the palace is festooned with around 200 bold carvings, which represent a unique collection of Scottish Renaissance sculpture. A devil, grotesque monsters and a line of armed soldiers face the outside. Classical deities and musicians decorate the inner courtyard. James V (top-left in the image to the left) is depicted in a more natural form with a bushy beard and wearing the Highland dress of the time. They would originally have been painted and gilded and were designed to proclaim the king's importance. R. W. Billings (1813–74), the Victorian architectural historian, described them as 'the fruits of an imagination luxuriant but revolting'.

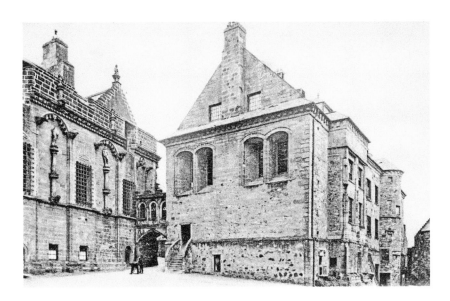

Castle, Great Hall

The Great Hall was completed during 1503, during the reign of James IV. It was intended as a magnificent venue for royal occasions and is the largest medieval hall in Scotland, requiring five fireplaces to heat it. The hall was used for the baptisms of James VI in 1566 and Prince Henry in 1594. The banquet following the christening of Prince Henry was a lavish affair with a huge boat floating in an artificial sea, dispensing sweetmeats and equipped with working cannons for a salute to the young prince. The hall was occasionally used for sittings of Parliament.

After the Union of the Crowns in 1603, the hall was no longer required for its original ceremonial uses and it was radically adapted by the military. Since the army moved out in the mid-1960s, the hall has been the subject of a major restoration scheme which has returned it to near its original condition. This has included the renewal of the spectacular hammer-beam roof and the controversial golden-yellow limewash. The restored Great Hall was opened by Elizabeth II on 30 November 1999.

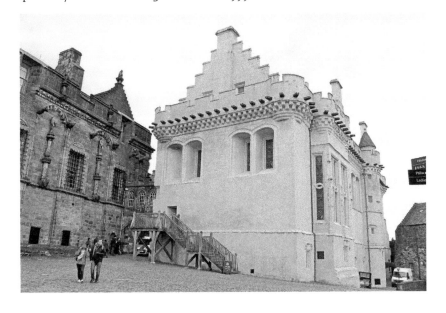

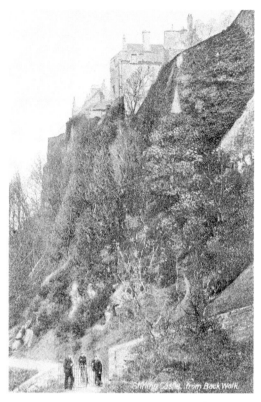

Castle from Back Walk

The Back Walk was constructed under the
patronage of William Edmonstone, the
Laird of Cambuswallace. It was originally
built in 1724 from the rear of the former
High School to Lady Hill and was extended
in the 1790s to Dumbarton Road and
around the castle to the Gowanhill.
It follows the historic city walls and
provides stunning panoramic vistas of the
surrounding area. It is known as the oldest
publicly maintained road in Scotland.

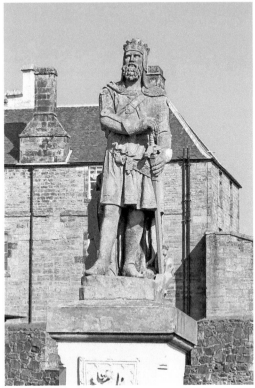

The Bruce Monument, Castle Esplanade
The 11-foot-high statue of Bruce on the
Castle Esplanade depicts Bruce sheathing
his sword after the victory at Bannockburn.
The inscription on the monument reads,
'King Robert the Bruce: June 24th, 1314' –
the date of the battle.

It was paid for by public subscription,
sculpted by Andrew Currie (1812–91) and
unveiled on the 24 November 1877 by Lady
Alexander of Westerton in the presence
of dignitaries, Scottish regiments and an
immense crowd of spectators.

When the statue was unveiled, 'the hero
of Bannockburn stood out in bold relief,
the face expressing conscious dignity,
and the whole figure manly bearing and
great courage, the enthusiasm of the vast
assemblage burst into loud cheers, which
were followed by a royal salute of cannon
from the ramparts of the Castle'.

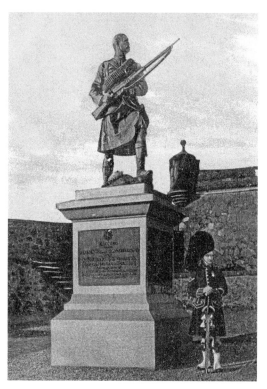

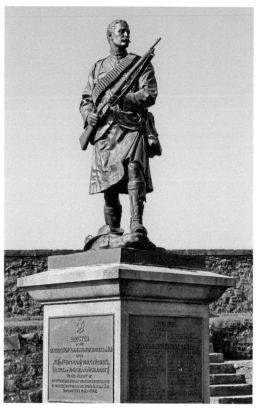

Argyll and Sutherland Highlanders South African War Memorial, Castle Esplanade
The Argyll and Sutherland Highlanders (Princess Louise's) have an association with Stirling Castle that dates back to 1881. The Regimental Museum at the castle, which opened in 1998, traces the regiment's illustrious history. The statue on the Castle Esplanade, by Hubert Paton, commemorates the regiment's 149 losses during the South African (Boer) War. It was unveiled on 12 January 1907 by Her Grace the Duchess of Montrose. The statue was removed for repair in November 2005 and was replaced in April 2006.

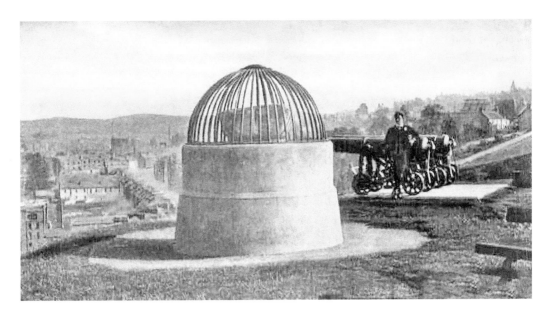

The Beheading Stone, Mote Hill

The beheading stone on Mote Hill was used for capital punishments in the fifteenth century. It is circular with a number of holes to hold the wooden beheading block. Heiding Hill, the alternative name for Mote Hill, alludes to the grizzly use of the site. The stone was used in the execution of some notable people including the Duke of Albany, his second son, Alexander, and his father-in-law, the Earl of Lennox in 1424. Sir Robert Graham and some of his associates in the assassination of James I were also executed in 1437 on Heiding Hill.

The stone is now on a concrete base and is protected by an iron grille, but you can still see the axe marks from the executions.

The Mote Hill was traditionally known locally as Hurly-Haaky (or Hurly-Hawkie), derived from a local pastime that involved sliding down the hill on a cow's head skeleton.

The two cannons were purchased by the town council from the army at Stirling Castle and moved to the hill for decorative purposes.

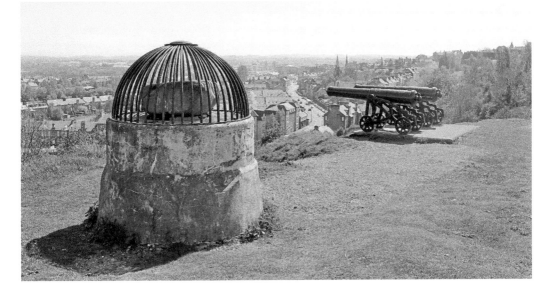

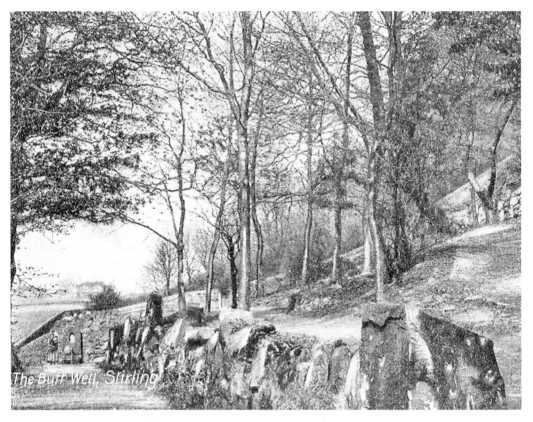

The Butt Well, Stirling

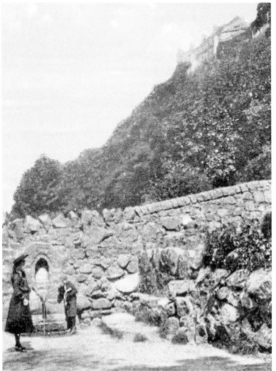

The Butt Well, Butt Park

The Well formed the termination of the early morning walk of the town's folk for a draught of its cold water, and was at a late period used by the wives and washerwomen of Stirling for washing their clothes, which were then bleached on the green sward lying below the Well, the tenant of the park making a charge according to the extent of the washing.

J. S. Fleming
Old Nooks of Stirling, (1898)

Butt Park takes its name from the area's historic use as an archery shooting ground. It was also the site of James V's jousting park.

The Butt Well was fed by a natural spring and has its origins in the sixteenth century, when it was known as the Spout Well. It was used for watering horses and was the source of the ornamental waters and fountains of the King's Knot. The present wellhead dates from 1842.

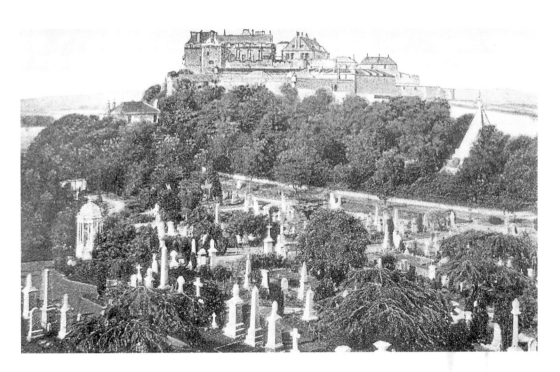

Valley Cemetery

'We know of no sweeter cemetery than that of Stirling.'

William Wordsworth

The Valley Cemetery was laid out in 1857–58 by Peddie and Kinnear as an extension to the kirkyard of the Church of the Holy Rude. It was previously an important open space between the castle and the town where jousting and public events, such as horse markets, were held. The rocky outcrop, which overlooks the cemetery, is known as the Ladies' Rock and formed an elevated vantage point for the ladies of the court to view the royal tournaments; it continues to provide panoramic views across the Trossachs and Ben Lomond.

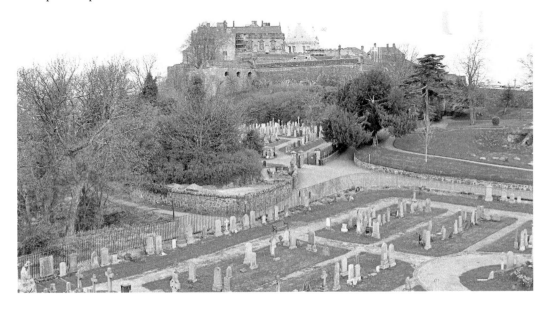

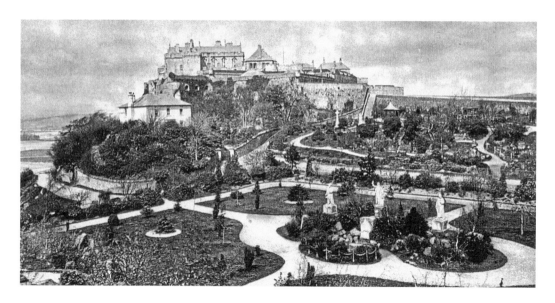

Valley Cemetery

The creation of the Valley Cemetery was due to Revd Charles Rogers. Rogers was chaplain at the castle and a town councillor. He was said to have had a degree of statue mania: he was responsible for the Wee Wallace on the Atheneum, Bruce on the esplanade, the Martyrs Monument and the statues of the heroes of the Scottish Presbyterian Reformation (John Knox, Andrew Melville, Alexander Henderson, James Renwick, James Guthrie and Ebenezer Erskine) in the Valley Cemetery.

The cemetery was largely funded by William Drummond (1793–1868). Drummond was a prominent Stirling businessman who is described as a 'seedsman, evangelist and an ardent Presbyterian'. He was the brother of Peter Drummond (1799–1877), the founder of Stirling's Drummond Tract Enterprise.

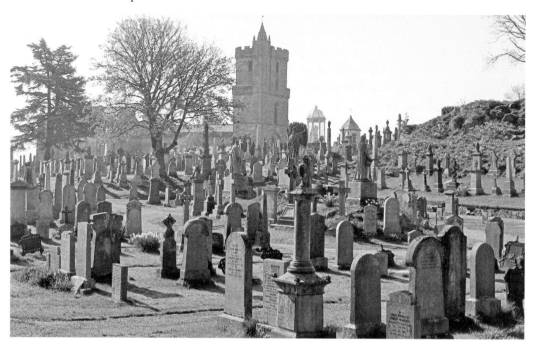

The Virgin Martyrs Monument

The Virgin Martyrs Monument depicts an angel watching over two young girls, with the older of the two reading the Bible to the other. It commemorates two young Wigtownshire girls, Margaret and Agnes Wilson, who were sentenced to death by drowning in 1685. The girls were Covenanters and refused to swear an oath of allegiance to Charles II, which amounted to them committing high treason.

Agnes, who was in her early teens, had her sentence commuted. However, Margaret (aged eighteen) along with an elderly neighbour, Margaret McLaughlin, were tied to stakes on 11 May 1685 in the Solway Firth and left to drown in the incoming tide.

The monument was erected in 1859 and the cupola was added in 1867. The sculptor was Alexander Handyside Ritchie (1804–70) and the cupola was by John Rochhead, the architect of the National Wallace Monument.

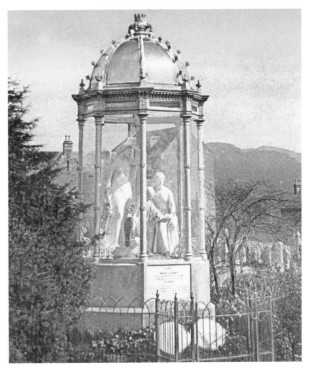

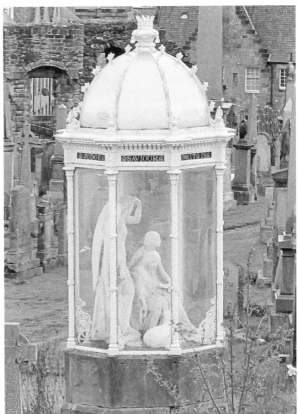

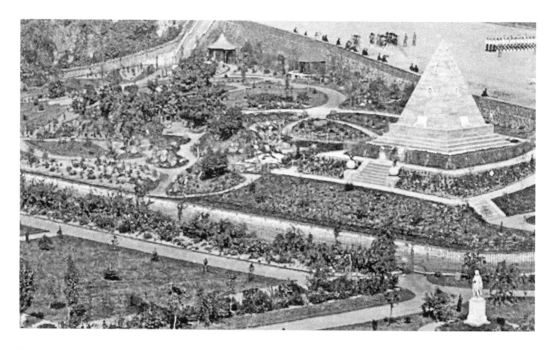

Drummond Pleasure Garden

As the name suggests, William Drummond, Stirling's prolific benefactor, was responsible for the Pleasure Ground which adjoins the Valley Cemetery. It was laid out in 1863 as a setting for the Star Pyramid, the largest pyramid structure in Scotland. The pyramid is dedicated to the cause of the Presbyterian Church in Scotland and also publicised his brother's Drummond Tract Enterprise. The pyramid form was popular at the time as a symbol of stability and endurance. Drummond's massive, polished, grey granite sarcophagus inscribed 'Born 14 February 1793 Died 25th November 1888' stands next to the pyramid.

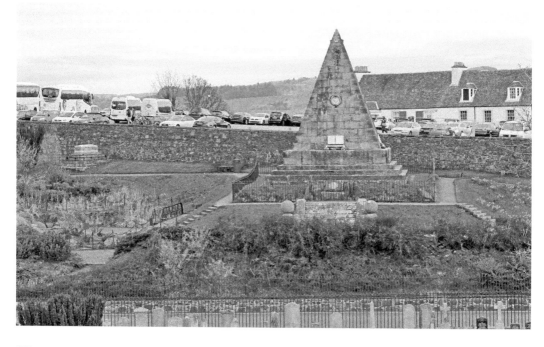

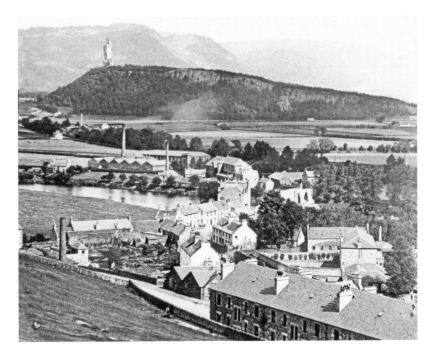

The view from Stirling Castle is the most beautiful of its kind that is to be seen in the United Kingdom.

J. G. Kohl, *England Wales and Scotland* (1844)

It is hard to disagree with Mr Kohl when it comes to this outstanding view to the Abbey Craig and the Wallace Monument with the Ochils in the background. It is 'a picture of natural beauty which is difficult to surpass'.

The earlier image is taken from around Gowan Hill looking towards the Old Stirling Bridge. It shows the huge Forth Mills on the opposite side of the river, houses on Lower Bridge Street and the town poorhouse (most of which has been redeveloped for housing and new roads).

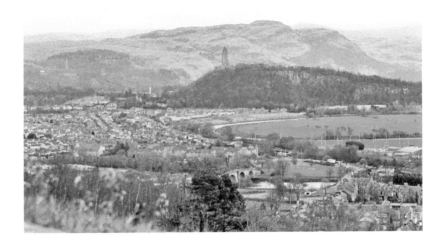

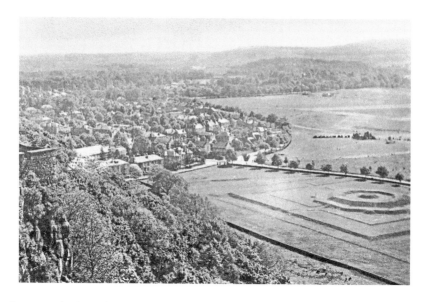

King's Knot, King's Park

The King's Knot, to the west of the castle and within King's Park, formed part of a magnificent seventeenth century formal garden. The Knot consists of a concentric stepped octagonal mound covered with grass. It originally formed the centrepiece of a surrounding rectangular parterre garden which would have been planted with box trees and ornamental hedges. The King's Knot is known locally as 'the Cup and Saucer'. A smaller, less distinct mound within the gardens is known as the Queen's Knot.

The gardens were built on the site of the Round Table, which is referred to in a 1530 poem 'Testament and Complaynt of our Soverane Lordis Papyngo', by Sir David Lindsay: 'Adieu, fair Snawdoun, with thy towris hie, Thy Chapill – Royal, Park, and Tabill Round'. Stirling had strong associations with King Arthur and it was long claimed that Stirling Castle was the Snowdon of Arthurian legend. The site was used for medieval jousting tournaments 'in the spirit of the Knights of the Round Table, which the courtly personages of former times are known to have been so fond'.

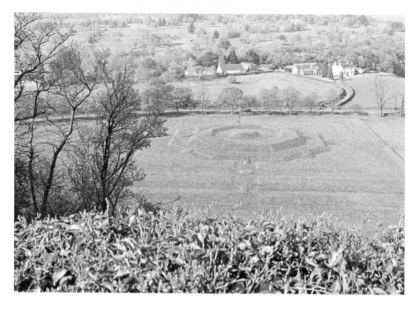

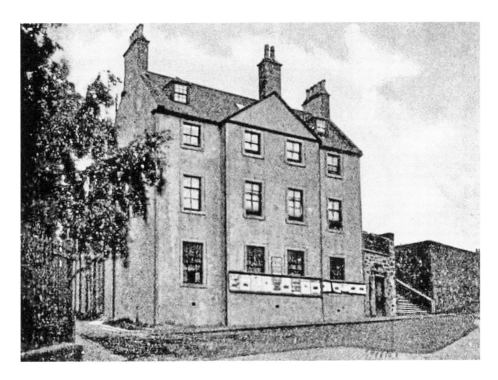

Old Grammar School, Castle Wynd

The building now occupied by the Portcullis Hotel was built in 1788 as Stirling's Grammar School on the site of an earlier grammar school that dated to 1470. There are records of a school in Stirling dating back to the twelfth century. The grammar school was the 'chief seat of learning in the burgh' until the opening of the high school in 1854. The building closed in 1856 and was used as a store by the Stirlingshire militia for a time before its conversion for hotel use.

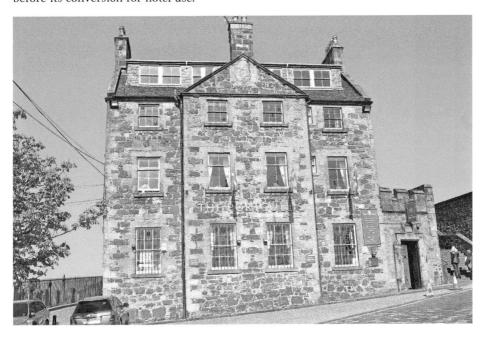

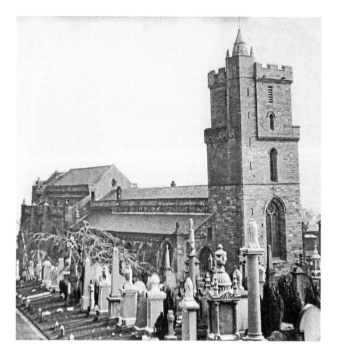

The Parish Church of the Holy Rude, Castle Wynd

The Parish Church of the Holy Rude is the original parish church of Stirling and one of Scotland's most important medieval buildings. A church was first established on the site in 1129 during the reign of David I (1124–53). Between 1371 and 1391, Robert II dedicated an altar to the Holy Rude (Holy Cross) within the church and it became known as the Holy Rude. The original church was destroyed along with much of Stirling in a devastating fire in 1405. The new church with its distinctive square belfry tower was rebuilt from 1414.

The church is closely associated with the monarchy. It was the venue for the coronation of Mary Queen of Scots on 9 September 1543 and the hastily arranged coronation of her son, the infant James VI, on 29 July 1567, after his mother was forced to abdicate. It is said to be the only existing church in the United Kingdom, apart from Westminster Abbey, to have hosted a coronation.

The walls of the church show signs of musket shot and cannon fire from battles around the castle.

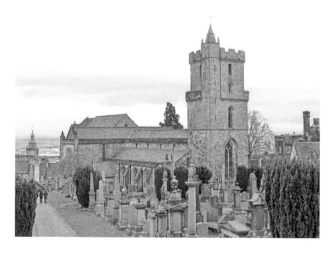

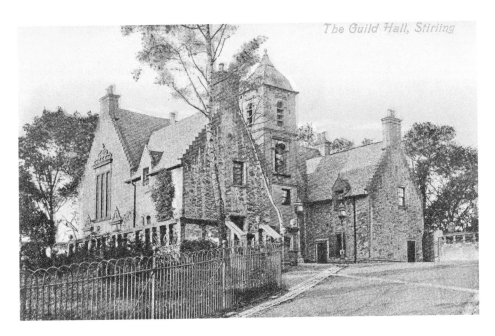

Cowane's Hospital – The Guildhall, St John's Street

The distinctive Cowane's Hospital was built between 1637 and 1648 as an almshouse for destitute members of the merchant guild. It was funded by a bequest in the will of John Cowane (1570–1633), a prosperous Stirling merchant. The building was reconstructed as a guildhall in 1852.

In the 1660s, the grounds were laid out with ornamental gardens and in 1712 Thomas Harlaw, gardener to the Earl of Mar, laid out a bowling green which is one of the oldest in Scotland. The cannons in the grounds were captured at Sebastopol during the Crimean War.

At the time of writing, the building is closed due to deterioration of the building fabric. However, Heritage Lottery funding has been allocated for repairs and conversion into a visitor attraction.

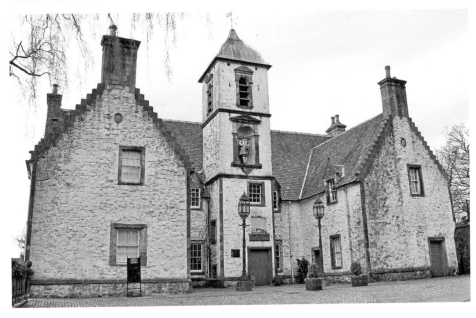

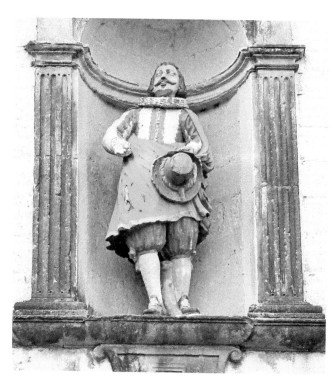

Auld Staneybreeks

Over the entrance to the Guildhall is a niche with a statue of John Cowane and the inscriptions: 'This Hospital was erected and largely provyded by John Cowane, Deane of Gild, for the Entertainement of Decayed Gild Breither. John Cowane, 1639' and 'I was hungrie and ye gave me meate, I was thirstie and ye gave me drinke, I was a stranger and ye tooke me in, naked and ye clothed me, I was sicke and ye visited me' (Matt. xxv. 35).

The statue of John Cowane is known as Auld Staneybreeks (old stone-trousers). There is a local legend that every Hogmanay, Auld Staneybreeks gets down for a dance in the courtyard.

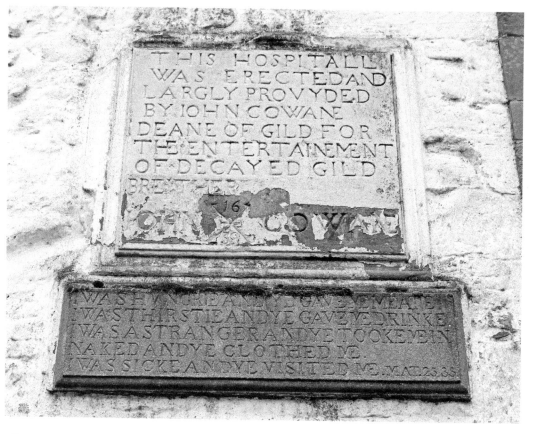

John Cowane's House, St Mary's Wynd

John Cowane was one of the Stirling's wealthiest and most influential merchants. He was also a ship owner, wine merchant, banker, town councillor, Member of Parliament for Stirling and Dean of the Merchant Guild. His house on St Mary's Wynd, which dates from 1603, was one of the largest in the town.

Cowane never married and lived at the house with his sister, Agnes – although in 1611 he was fined for fathering a child out of wedlock. The building was purchased by the Cowane's Hospital in 1924 and is now preserved as a picturesque ruin.

On his death in 1633, Cowane left large sums of money to numerous charitable causes in Stirling.

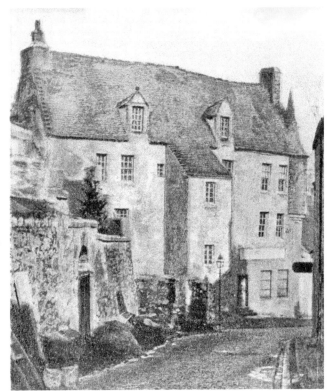

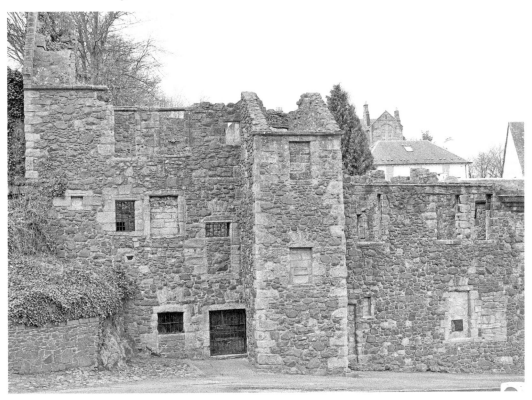

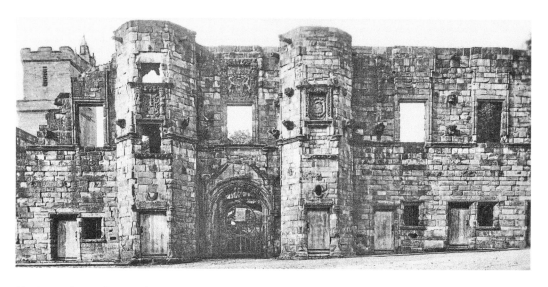

Mar's Wark, Castle Wynd

Part of the elaborate front facade of Mar's Work, which dominates the top of Broad Street is all that remains of the once-splendid town mansion of John Erskine, Earl of Mar. Mar's Wark, or Lodging, was commissioned in around 1569 by the influential Erskine, hereditary Keeper of Stirling Castle and one-time Regent of Scotland. The facade features an abundance of sculptures with the royal armorial bearings of Scotland over the entrance and the Erskine family heraldic panels on the two flanking towers. A number of humorous rhyming inscriptions are also included:

I pray all luikaris on this luging, With gentile E to gif thair juging.
I pray all lookers on this lodging, with gentle eye to give their judging.
The moir I stand on oppin hitht. My faultis moir subject ar to sitht.
The more I stand on open height, My faults more subject are to sight.
(I am conspicuous, so my mistakes are more apparent)

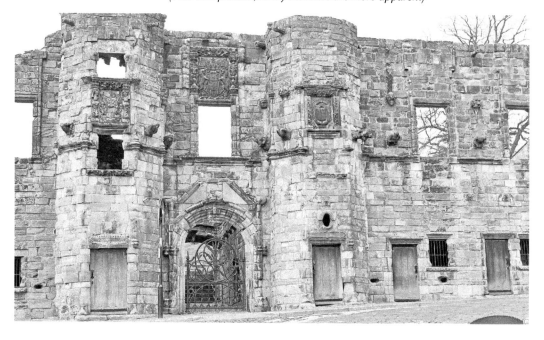

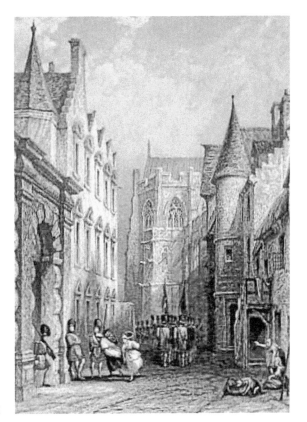

Castle Wynd

The proximity to the castle made Castle Wynd one of the most significant parts of the town and a number of Stirling's most noteworthy historic buildings were built in the area: Mar's Work, the Argyll Lodging and the Church of the Holy Rude.

The older image shows Mar's Work in a more complete state, with conical roofs on the octagonal towers. Mar's Work was converted into barracks after the 1715 Jacobite rebellion and was badly damaged during the 1746 siege of the castle. The building ended its life rather ignominiously as the town workhouse.

Much of the stone used in the construction of Mar's Work was salvaged from the ruinous Cambuskenneth Abbey and Mar's Work itself was subsequently used as a quarry for other building projects. It is said that the only reason that it survived in any form was due to the fact that it sheltered the market place from the winds whistling down Broad Street.

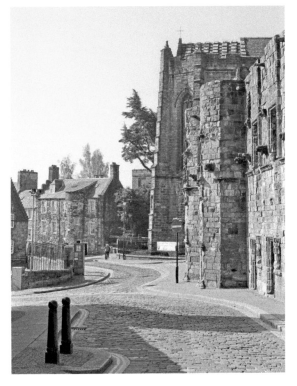

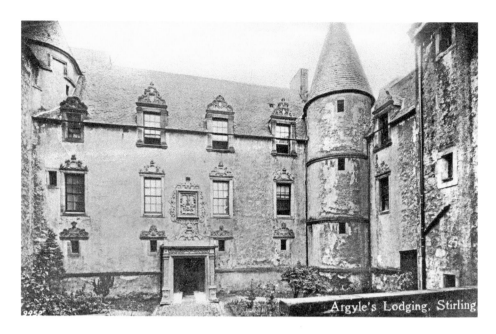

Argyll's Lodging, Castle Wynd – Courtyard

Argyll's Lodging is the most important and complete surviving seventeenth-century town house in Scotland. It sits behind a screen wall on Castle Wynd on the final approach to the castle.

The Lodging was developed from a small sixteenth-century house in a number of phases and by a number of owners. In 1629, Sir William Alexander was the new owner and had the house enlarged and remodelled. Sir William was involved in the settlement of Nova Scotia and an armorial tablet on the wall above the main entrance displays Alexander's coat of arms with the shield supported by a Native American. Scrolls show his family motto '*Avt Spero Avt Sperno*' and the motto of Nova Scotia '*per mare per terras*'.

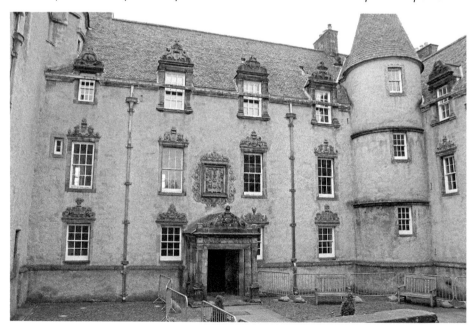

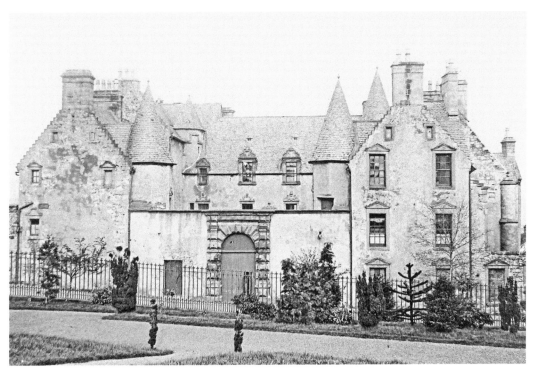

Argyll's Lodging, Castle Wynd – Street View

Archibald Campbell, 9th Earl of Argyll bought the house in 1666 and made significant enlargement and alterations – the courtyard was enclosed behind a screen wall and an elaborate entrance gate installed.

In 1764, the fourth duke of Argyll sold the house and it remained in domestic use until 1800, when it was purchased by the army for use as a military hospital. It became a youth hostel in 1964. In 1996, it was restored to its historic splendour and opened as a museum.

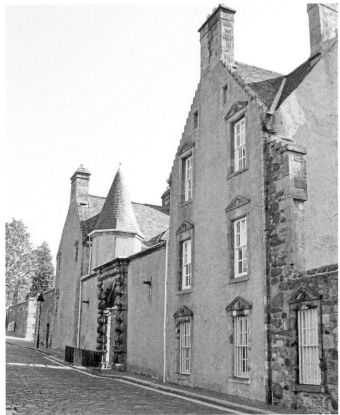

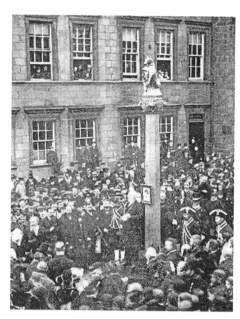

Broad Street Mercat Cross

Mercat crosses were a symbol of a town's right to hold a market and an important privilege. It marked the spot where trade was carried out and public proclamations were made. Stirling was granted the right to hold markets as early as 1226 by Alexander II. In 1792, the mercat cross was moved from a central position on the street to ease traffic movement. It was reinstated in 1891 and unveiled on 23 May in front of a large crowd.

It consists of an octagonal shaft on a stepped circular base and is surmounted by a unicorn (known as 'the Puggy') with a lion rampant and St Andrew's Cross. Only the Puggy dates from the original sixteenth-century mercat cross.

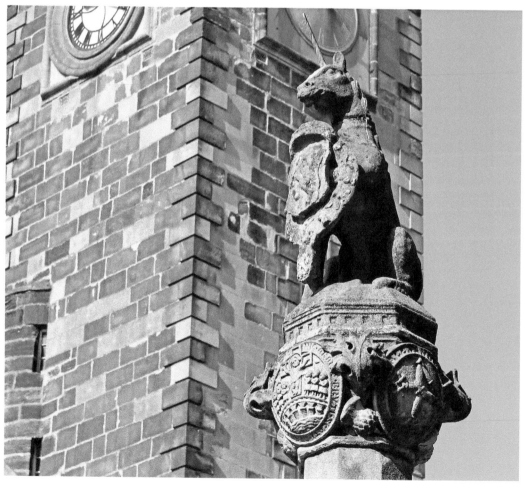

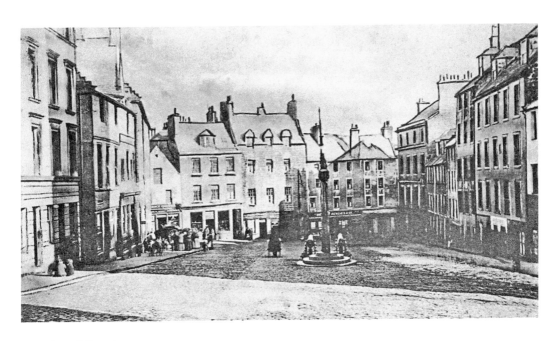

Broad Street

Broad Street, anciently named Hiegait, and afterwards High Street, was once the market and chief place of business. Here were the Tolbooth, the Mercat Cross and the Tron. It was here also the weekly markets and annual fairs were held, stances being allotted to the various trades, whose wares were exposed on staiks or stalls. During the sixteenth century, this spacious street contained the ludgings, or mansions, of the noblemen and Church dignitaries attached to the Court during the Royal residence in the Castle. The principal municipal officials had also their residences in the street.

Merchants' Guide to Stirling (1897)

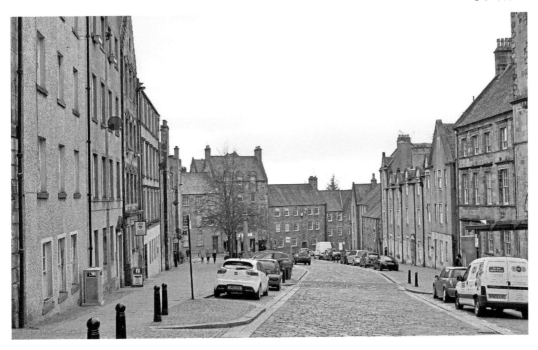

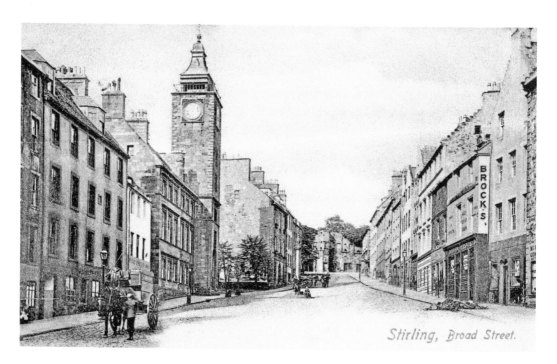

Stirling, Broad Street.

Broad Street

The original Tolbooth was erected in around 1473, then partially rebuilt in 1563 due to its dangerous condition. It was taken down and rebuilt, with the addition of the steeple, in 1703–05, according to 'ane drauglit or sceme' prepared by Sir William Bruce of Kinross. The street at the front of the Tolbooth was one of the places where wrongdoers were executed or otherwise punished. It was adapted as a gallery and venue in 2001.

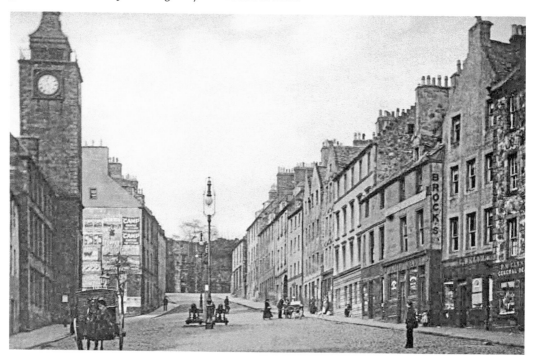

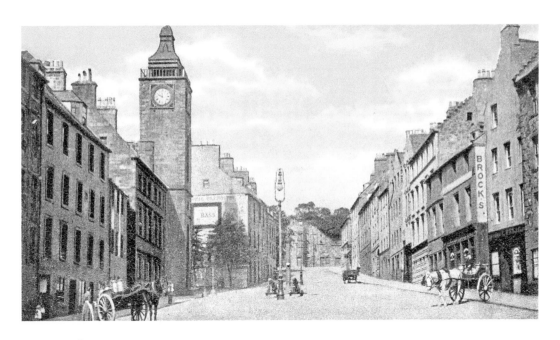

Broad Street

The arrival of the railway in 1848 was an incentive for development closer to the station and beyond the medieval burgh walls, which drew commercial activity away from the top of the town. By the early twentieth century, Broad Street was in need of improvement, with many of the buildings in a seriously dilapidated condition. From the 1930s, the area underwent extensive regeneration under the guidance of the architect Sir Frank Mears (1880–1953). Key historic buildings were restored and the reconstruction was in a traditional Scots style.

The cannons in the more recent image were made by Carron Iron Works. They were purchased by Stirling Council from the War Office in 1904.

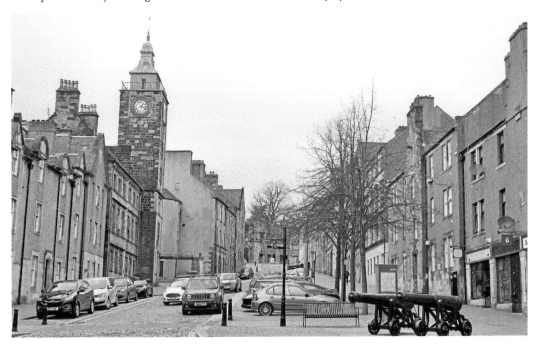

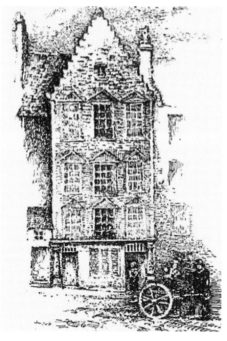

Town Clerk Norrie's House

Norrie's House is an original, but much restored, seventeenth-century property which is marked with the inscription '1671'.

The frontage includes a number of inscribed religious and moral precepts: '*IN SOLI DEO GLORIA A R*' (Glory to God alone), '*ARBOR VITAE SAPIENTIA*' (Wisdom is the tree of life) and '*MURUS AHENEUS BONA CONSCIENTIA*' (A good conscience is a brazen wall).

The inscribed initials 'IN' and 'AR' relate to Norrie and his wife, Agnes Robertson. Different sources give the initials as Norrie's sister-in-law Jean Robertson and her husband or Agnes Robertson's parents.

> James Norie, who seems to have had a good standing in his profession of notary, succeeded William Barclay as Town Clerk in 1650, and appears almost continuously to have retained his office down to 1679. He is shown by the Burgh Records to have been a discreet and efficient servant, and entrusted with many important commissions.
>
> J. S. Fleming
> *The Old Ludgings of Stirling* (1871)

A wigged figure on the frontage may relate to Norrie's profession.

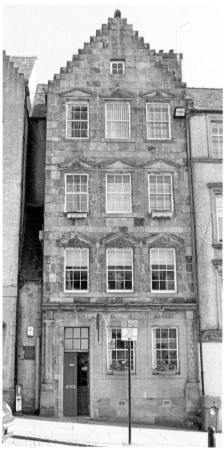

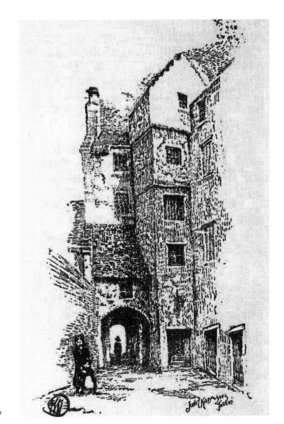

Broad Street, Darnley's House

One of the few remaining historic houses fronting the foot of Broad Street has an inscribed stone, reading:

> Darnley House, the Nursery of James VI
> and of his son Prince Henry.

However, there is no evidence to support the statement. The house was the property of Alexander Erskine of Canglour, whose son Thomas, Earl of Kellie, sold it to Jonet Kilbowie, who, between 1650 and 1660, ran it as a tavern which was a noted rendezvous of the magistrates and town council. In 1651, the Stirling authorities surrendered to Cromwell's General Monck in the tavern.

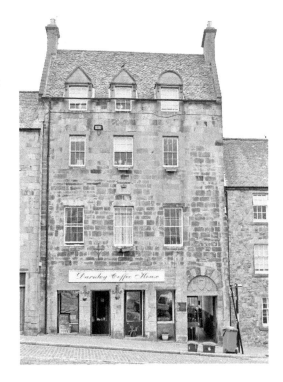

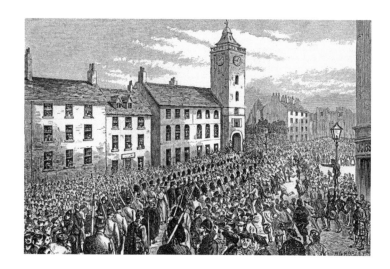

The Stirling Political Martyrs

A small plaque on the Tolbooth commemorates the brutal public execution of John Baird and Andrew Hardie in Stirling on 8 September 1820. Baird and Hardie were activists involved in the Radical War or Scottish Insurrection – a period of strikes and conflict in which workers demanded a more representative government, the end to economic depression and fair wages. The authorities feared the kind of revolutionary turmoil that had been seen in France some decades earlier and were intent on the ruthless suppression of the rebellion.

On 5 April 1820, Baird and Hardie were the leaders of a small group of radicals that were marching on Carron Ironworks, near Falkirk, with the intention of seizing weapons. They were apprehended by government troops near Bonnybridge, along with a number of others, and imprisoned at Stirling Castle. After being tried and found guilty of treason, they were sentenced to be hanged and beheaded. The grim execution took place at the Tolbooth in front of a crowd estimated to have been 2,000. It seems that the Stirling hangman refused to carry out the grisly deed and the job was done by a 20-year-old Glasgow medical student.

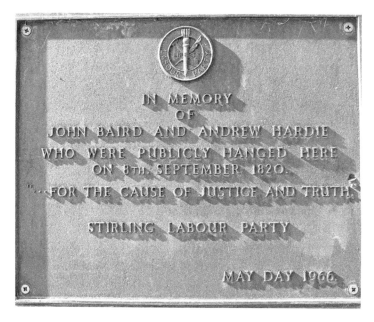

Granny Duncan and Penny Millar's Slap

Penny Millar's Slap was a narrow lane leading from Upper Castlehill to the Esplanade, which took its name from a Mr Millar who was tacksman of the petty (penny) customs of the burgh.

Granny Duncan was one of the best-known residents of Penny Millar's Slap. She earned a livelihood by keeping pigs and also providing milk and coffee for the soldiers in the castle.

Granny Duncan showed great kindness to Baird and Hardie, the political martyrs, when they were in Stirling Castle awaiting execution by smuggling letters and food into their cells. Both Baird and Hardie requested that Granny Duncan should attend after their executions to dress their bodies and place their heads in the respective coffins. On the day of the execution, it is said that Hardie called out from the scaffold, 'Are you there, Granny?', to which she replied, 'Aye, Andrew, my puir laddie'; 'Bide to the end, then', were Hardie's last words to her. After the grim executions, she fulfilled the task they had set her.

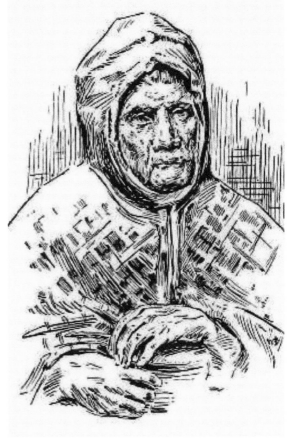

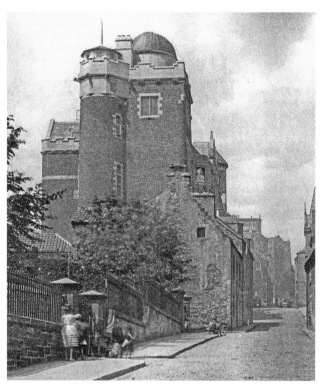

The Old High School, Spittal Street/Academy Road
This view shows the 1887–90 extension, by James Marjoribanks MacLaren, to the earlier school. The revolving copper-domed observatory at the top of the building still includes the original Newtonian telescope. The school was converted into the Stirling Highland Hotel in 1990.

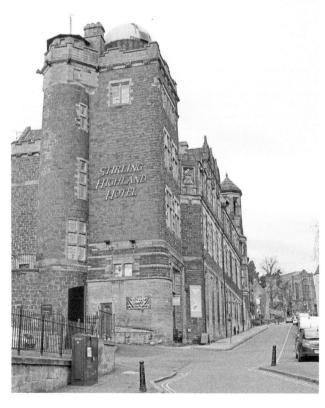

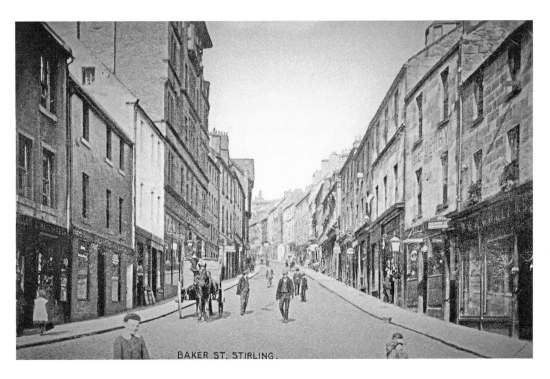

Baker Street

Baker Street was previously called Baxter's Wynd. At one time it was the main road through Stirling, which is reflected in the number of closely packed shops in the earlier image. The street has been the subject of a substantial amount of reconstruction from the 1930s.

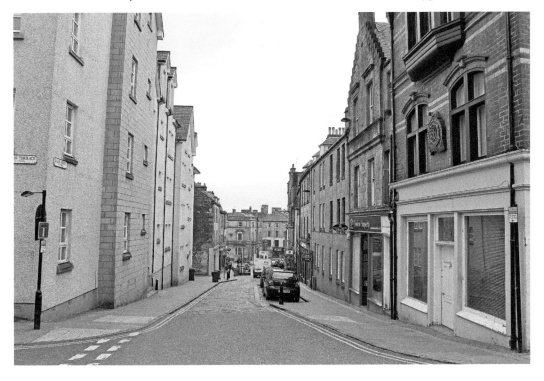

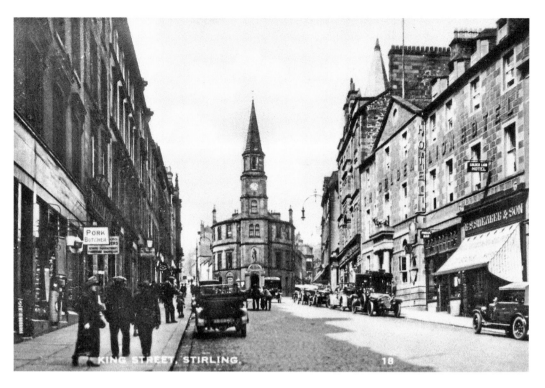

King Street

King Street was part of the old *Hie Gait* or High Street of Stirling. In 1820, the name Quality Street was changed to King Street on the Coronation of George IV. The location of the New Port, one of the Burgh Gates, is marked on the roadway outside the Golden Lion Hotel.

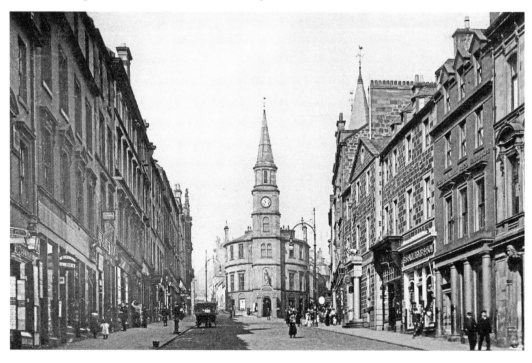

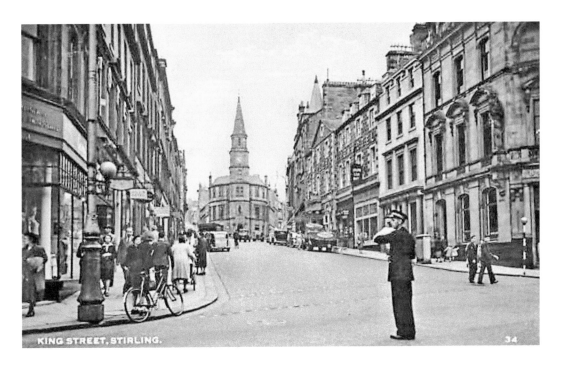

KING STREET, STIRLING. 34

King Street

The building on the right at the foot of the street was erected for the Stirling Tract Enterprise by Peter Drummond in 1862. Peter Drummond established the Stirling Tract Enterprise in 1848 when he published a booklet on Sabbath desecration in relation to the operation of the Cambuskenneth Ferry on a Sunday. It became the foremost nineteenth-century publisher of religious pamphlets. The building was used as a branch of the British Linen Bank when the increase in the Tract Enterprise's business made a move to larger premises necessary.

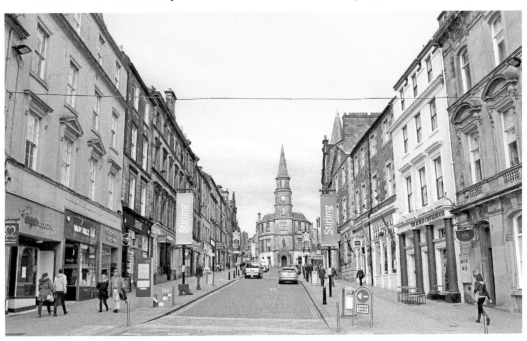

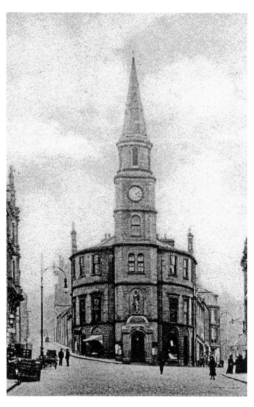

Atheneum, King Street

The building with the Gothic spire at the head of the street dates from 1816. It was built as town offices, a library and reading rooms above two shops. It was known, rather grandly, as the Atheneum, from the Latin for 'a place of learning' but it is more widely known locally as 'the Steeple'.

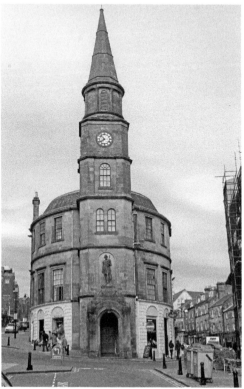

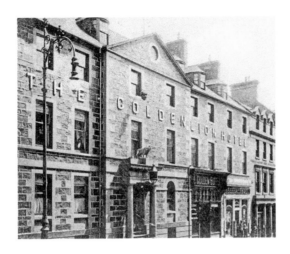

The Golden Lion Hotel, Nos 8–10 King Street

The Golden Lion Hotel first opened its doors to visitors in 1786 as Wingate's Inn after James Wingate, a local businessman, who had commissioned the new hotel – the architect was Gideon Gray. It stood on the site of the Gibb's Inn Tavern, an earlier coaching inn.

On 26 August 1787, Robert Burns visited Stirling Castle on his Highland tour and stayed at Wingate's. At that time, the castle was in a dilapidated condition and this encouraged Burns to use a diamond pen to scratch the famous 'Stirling Lines' on a pane of glass in his bedroom:

> Here Stewarts once in glory reign'd,
> And laws for Scotland's weal ordain'd;
> But now unroof'd their palace stands,
> Their sceptre fallen to other hands:
> Fallen indeed, and to the earth,
> Whence grovelling reptiles take their birth!
> The injured Stewart line is gone,
> A race outlandish fills their throne:
> An idiot race, to honour lost -
> Who know them best despise them most...

On a return visit in October 1787, realising that the poem had caused offence and its pro-Jacobite sentiment was potentially treasonable, Burns smashed the pane of glass.

The lines were inscribed in stone at the entrance to the Stirling Smith Museum on 12 March 2002, the day that Stirling became a city.

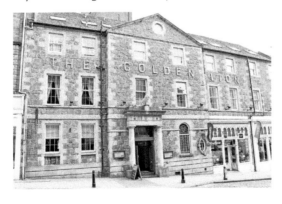

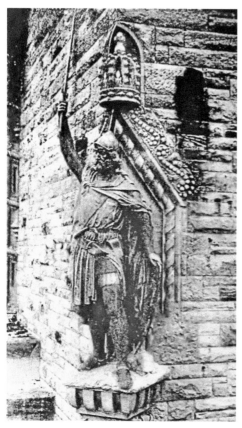

Wee Wallace and Big Wallace

The statue on the Atheneum at the top of King Street is known as the 'Wee Wallace' to distinguish it from the larger statue of Wallace by David Watson Stevenson on the National Wallace Monument. It portrays Wallace in classical garb with a sword on his back and holding a horn. It was sculpted by Handyside Ritchie for William Drummond and was originally situated in Drummond's own garden. In 1859, it was presented to the town and a new porch was added to the building with the statue on top. The motto *'Nemo me impune laccesit'* (No one shall attack me with impunity) inscribed on the porch is the motto of Scotland.

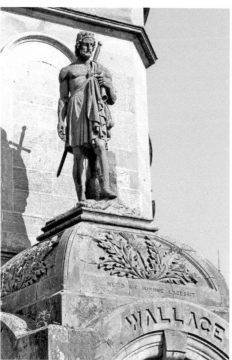

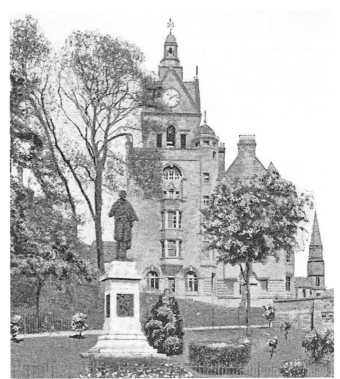

Stirling's municipal buildings are a fine example of Edwardian civic building design which reflects the burgh's historic importance. The design was the result of a competition won by John Gaff Gillespie (1870–1926) in 1908. The foundation stone was laid on Saturday 11 July 1914 by George V. However, because of unrest in the town (due to the expenditure on the building at a time when many people were living in slum housing), this had to be done by remote control with the king safely ensconced at the county buildings in Viewforth. Due to the First World War, work was delayed and the building did not open for business until 1918.

Robert Burns (1759–96), the National Bard of Scotland, is depicted in more statues around the world than any other literary figure. Stirling's bronze statue of Burns by Albert H. Hodge was gifted by Provost Bayne and unveiled on 23 September 1914 by his daughter. During a visit to Stirling in August 1787, Burns wrote, '...just now, from Stirling Castle, I have seen by the setting sun the glorious prospect of the windings of River Forth through the rich carse of Stirling.'

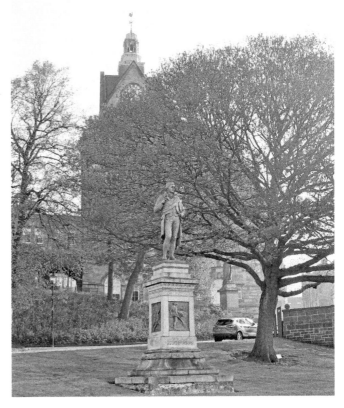

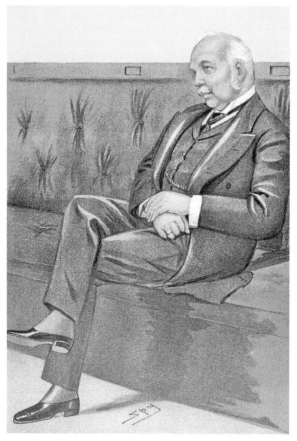

Sir Henry Campbell-Bannerman's
statue overlooks the city that he
served and did much to shape.
Campbell-Bannerman (1836–1908)
was the Member of Parliament
for the Stirling Burghs, which he
represented for forty years, from
1868 until his death in 1908. He
rose rapidly through the ranks of
the Liberal party, became leader in
1899 and was Prime Minister from
5 December 1905 until 3 April 1908.
He has the honour of being the
first person to have the official title
Prime Minister (the former title of
the position was First Lord of the
Treasury). Campbell-Bannerman's
government introduced a number
of social reforms based on his
Liberal beliefs. He resigned as
Prime Minister on 3 April 1908
due to ill health, following a
series of heart attacks, and he
was replaced by Henry Asquith.
Campbell-Bannerman continued to
live at No. 10 Downing Street until
his death on 22 April 1908; he is the
only former Prime Minister to die
within the building.

The statue of Campbell-Bannerman
by Paul Montford was unveiled on
1 November 1913 by Prime Minister
Herbert Asquith. Asquith, who
opposed votes for women, was set
upon by suffragettes at Bannockburn
on his way to the unveiling
ceremony.

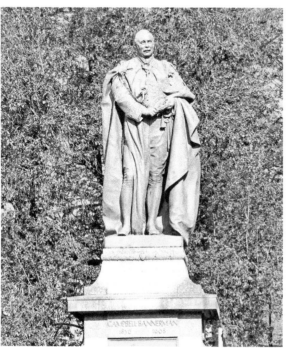

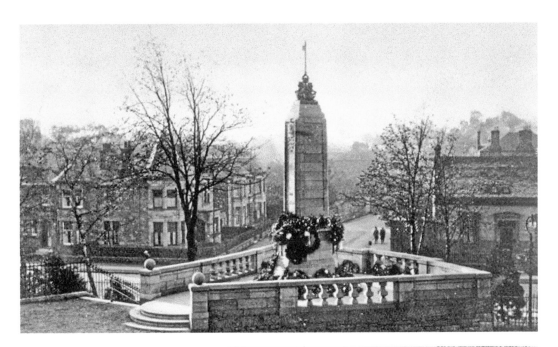

Stirling War Memorial, Corn Exchange Road

The Stirling War Memorial was designed by Stirling architect George R. Davidson and unveiled on 14 October 1922 by Field Marshall Earl Haig. It consists of a square column in a walled enclosure, topped by a flagpole with bronze wreaths on each side and two lions holding a crown. The inscription reads:

> In Proud And Grateful
> Memory Of The Men Of
> Stirling Who Gave Their
> Lives In The World War
> At The Going Down Of The
> Sun And In The Morning We
> Will Remember Them
> This Memorial Was Unveiled
> By Field Marshall Earl Haig
> 14th October 1922.

It is a fittingly prominent memorial to the 711 men of Stirling who gave their lives in the First World War and 211 in the Second World War. The memorial was restored in 2014.

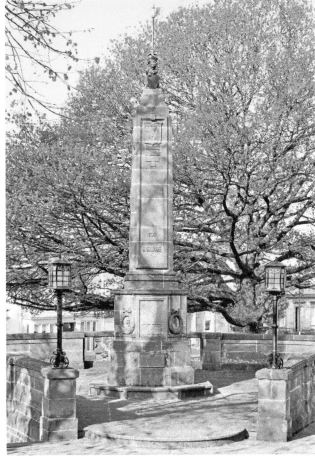

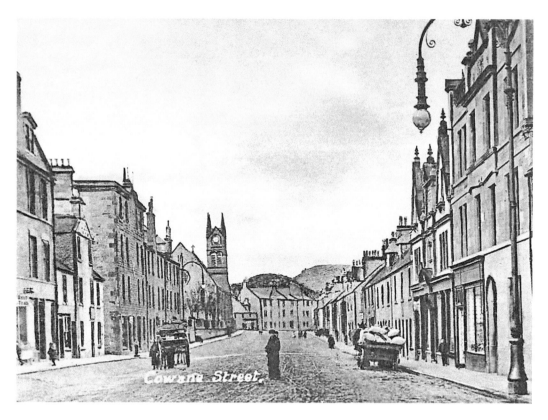

Cowane Street

Cowane Street takes its name from Stirling's influential merchant, John Cowane. There has been some considerable change in the street including the loss of the fine West Free Church (in the background to the left of the image above) with its clock tower, which dates from 1881 to 1882.

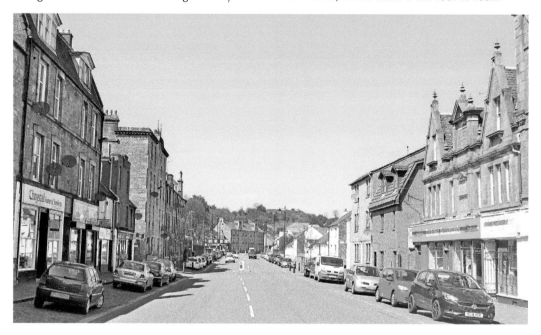

Black Boy Fountain and George Christie Memorial Clock, Allan Park

The Black Boy Fountain and George Christie Memorial Clock are located in Allan Park, a small green area at the junction of King's Park Road and St Ninians Road.

George Christie (1826–1904) was a well-known businessman in Stirling who was provost between 1870 and 1879. The clock was unveiled in 1906 and restored in 2006.

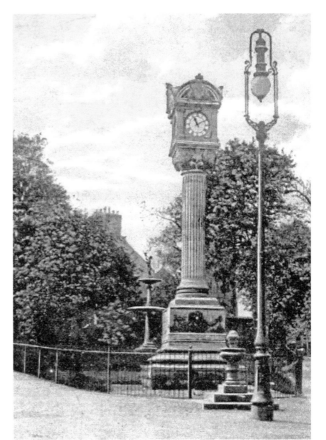

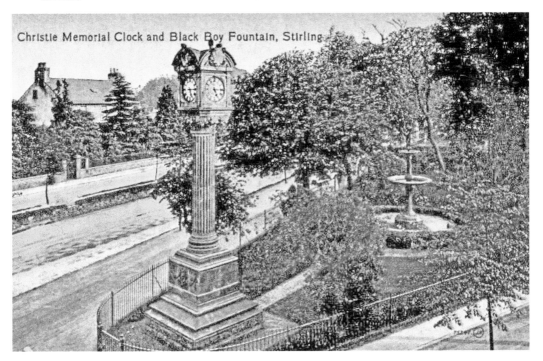

Christie Memorial Clock and Black Boy Fountain, Stirling

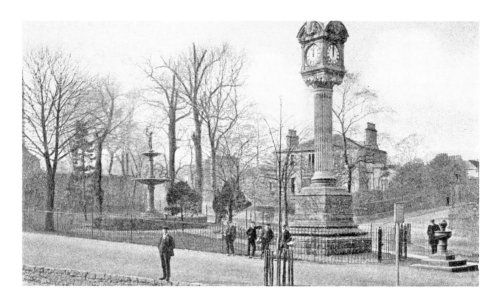

Black Boy Fountain, Allan Park

The distinctive Black Boy Fountain was erected in 1849 to commemorate the outbreak of bubonic plague in the town in 1360 which, in the cramped conditions within the city walls, killed one-third of the population at the time. The fountain was manufactured by the Neilson Foundry of Glasgow and was restored in 1997 by the Ballantine Ironworks of Bo'ness as part of a regeneration project for Stirling town centre. The fountain stands on the seventeenth-century site of public execution and burial – 'the Gallous Mailing'. It seems that at some point the fountain was made more respectable for public display by the removal of part of his anatomy.

The art deco building in the background of the recent image was built as the Allan Park cinema, which opened in 1938.

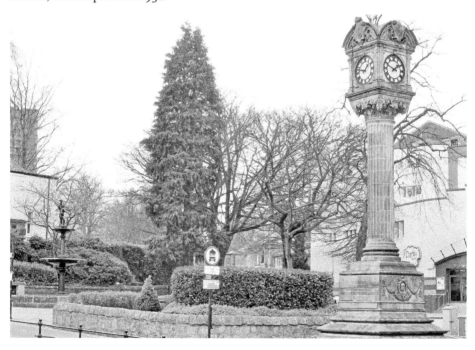

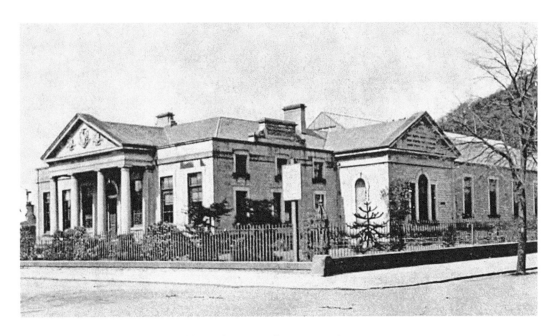

Stirling Smith Museum, Albert Place, Dumbarton Road

The Smith Institute was paid for by a bequest of £22,000 from Thomas Stuart Smith of Glassingall, Perthshire and opened on 11 August 1874. It was an event for celebration in Stirling, with shops closing early to allow people to attend the opening. Smith was a talented artist and donated his own paintings and art collection to the Institute. The Institute originally contained a picture gallery, museum and a reading room. It is now known as the Stirling Smith Art Gallery & Museum, and it is a significant cultural and community asset for Stirling.

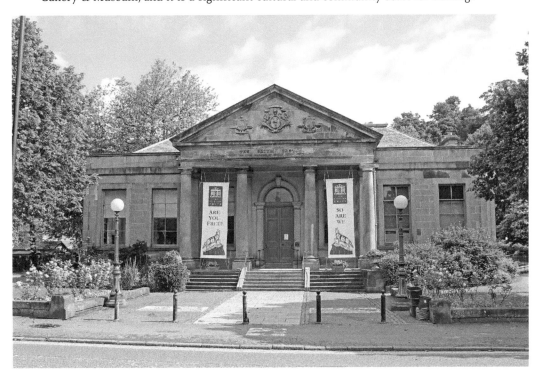

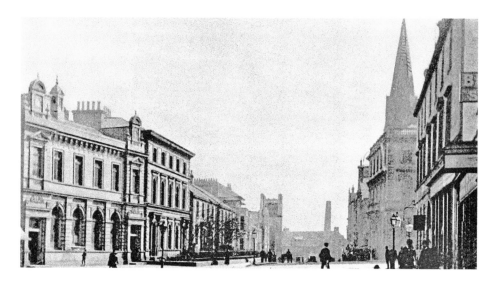

Murray Place

Murray Place was originally a narrow lane leading to orchards around the site of the railway station. It was developed in 1842 to connect King Street to the new bridge over the River Forth and to reduce traffic through the upper part of the town. It was named after William Murray of Touchadam and Polmaise (1773–1847), who was the Lieutenant Colonel of the Stirlingshire Yeomanry in 1843 and influential in the formation of the new street; Maxwell Place was also named for his wife, Anne Maxwell (1799–1846). Murray Place became commercially more important when the railway arrived in 1848. It remains a prosperous street, lined with substantial Victorian buildings.

The building in the left foreground was built as the new post office which first opened for business on 24 May 1895. The building next to this was the National Bank of Scotland, which dates from 1855. A church and monastery, which were founded by Alexander II in 1233, were located around the site of the bank and are commemorated in the street name Friars Wynd.

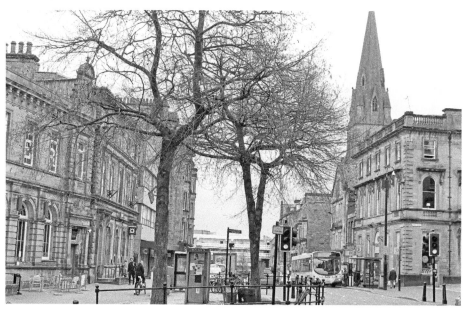

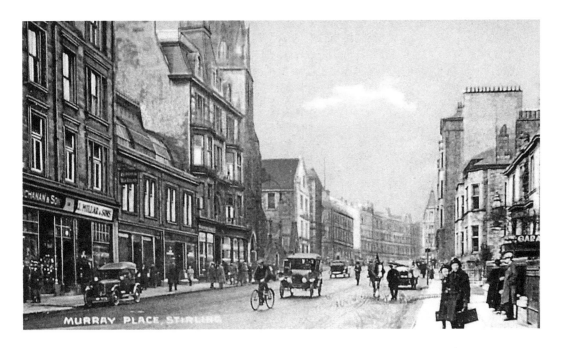

Murray Place

The Stirling Arcade building can be seen in both of these views of Murray Place. It is one of only five shopping arcades in Scotland and was built between 1881 and 1882 for William Crawford, a Stirling merchant and town councillor. The arcade links Murray Place to King Street and originally contained: two hotels (the Douglas in Murray Place and the Temperance in King Street); a theatre (later a cinema), which hosted many well-known variety performers; thirty-nine shops; and a number of residential flats. It remains an important historic asset and a unique shopping environment.

Stirling Baptist Church (formerly South Church) next to the Stirling Arcade building, dates from 1851 to 1853 and its spire is a local landmark.

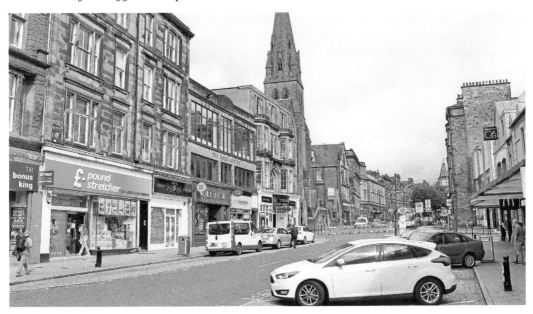

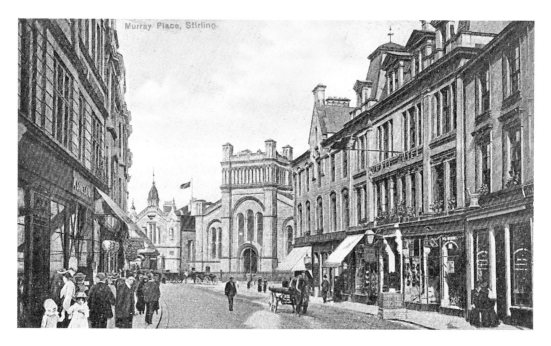

Murray Place

The construction of the Thistles Centre, in the early 1970s, resulted in significant alterations to the street including the loss of the Norman-style North Parish Church, with its low and massive square tower, which dated from 1843 and the Gothic-fronted Baptist Chapel of 1854. The Thistles Centre also resulted in the loss of Orchard Place, which ran parallel to the east of Murray Place. Early maps show Orchard Place lined with an iron foundry and a coach-building factory.

Mill Lane ran at right angles to the east of Murray Place at the present main entrance to the Thistles Centre. It included the May Day Yard, which had stables for the stagecoach horses prior to the opening of the railway, and was later used as a coal depot and the town gasworks.

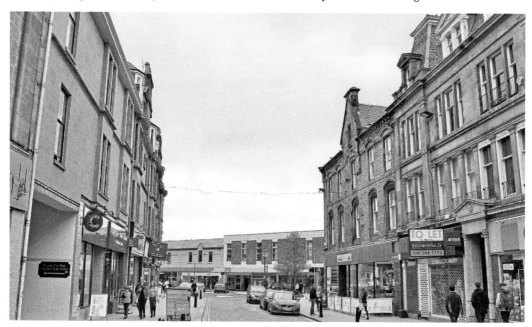

Murray Place

Two early views looking north on Murray Place, towards the demolished North Church. The Drummond Tract Enterprise building is prominent in the right foreground of the image below. It was richly decorated with sculptured heads of 'Reformers and Divines' and with two angelic figures on the upper level of the splayed corner. The sign on the right of the colour image relates to the Olympia Halls, which first opened in 1909 as a roller-skating rink and was converted to a 'Picture Palace' in 1911.

The County Hotel is prominent in the image to the right.

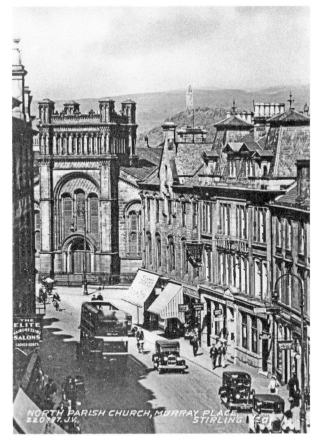

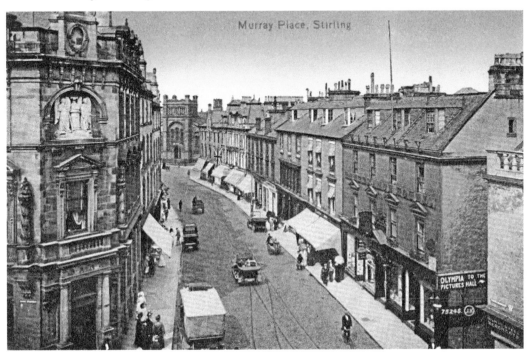

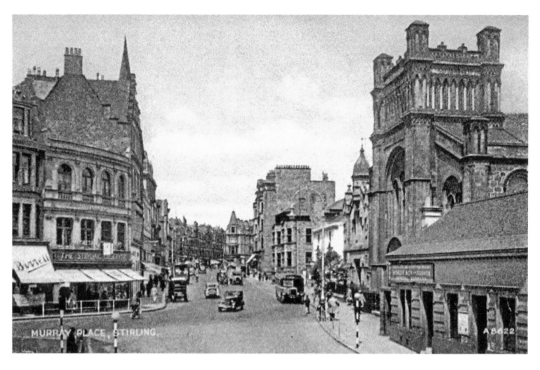

Murray Place

The older image provides a closer view of the North Church and the smaller baptist church which have since been replaced by two-storey shops.

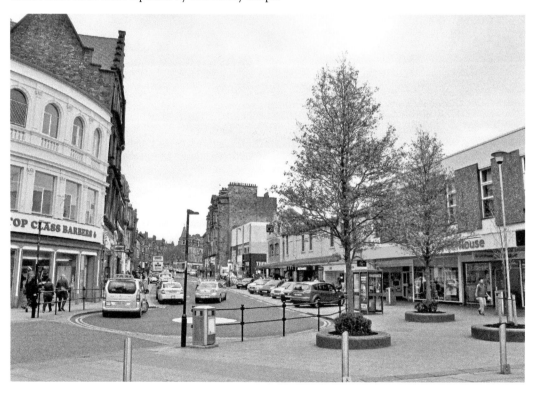

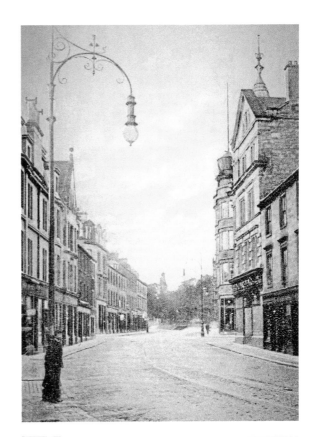

Port Street

Apart from the addition of modern street furniture, this view, looking towards the south on Port Street, is relatively unchanged over the 100 years that separate the two images. The distinctive red brick Wolfcraig Building is prominent to the right of both pictures.

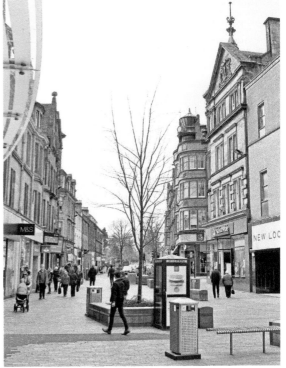

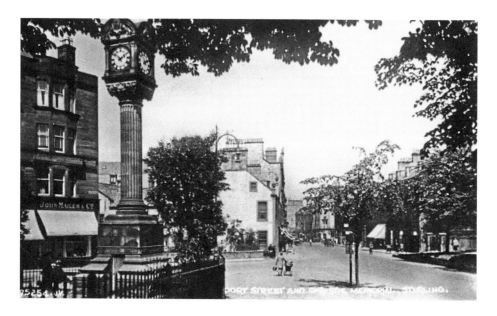

Port Street

Looking north on Port Street, with the George Christie Memorial Clock prominent in the foreground.

Port Street takes its name from the Barras Yett, the main burgh gate, which was the principal entrance to Stirling from the south in the days when the town wall existed in full. It was located at the junction of Port Street and Dumbarton Road and is marked by a brass plaque on the pavement. It was the main entry point for traffic from the south. The historic route through the town then passed into King Street before ascending Spittal Street and Bow Street to the bottom of Broad Street. It then descended by St Mary's Wynd towards Stirling Old Bridge. The demolition of the Barra Yett in 1770 allowed the development of new streets – Port Street, Murray Place and Barnton Street – at the edge of the old burgh.

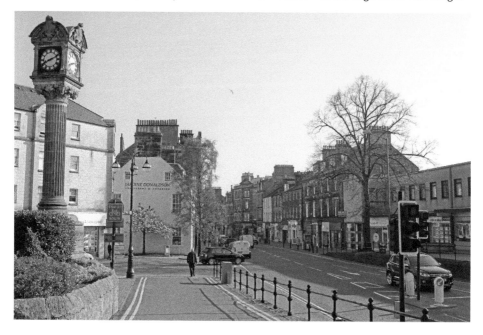

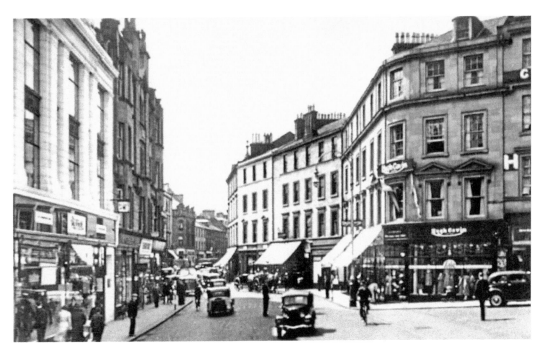

Port Street

Looking south on Port Street, the Hugh Gavin shop on the corner of Port Street and King Street was a long-established retailer in Stirling.

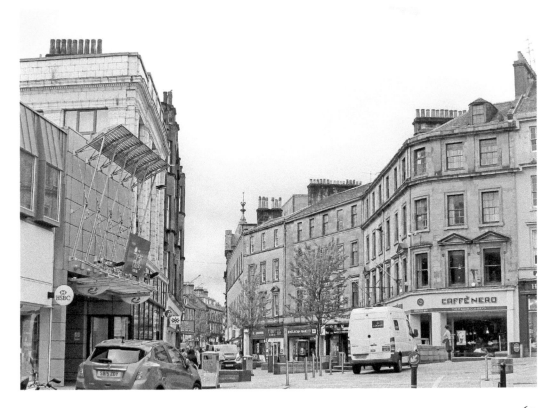

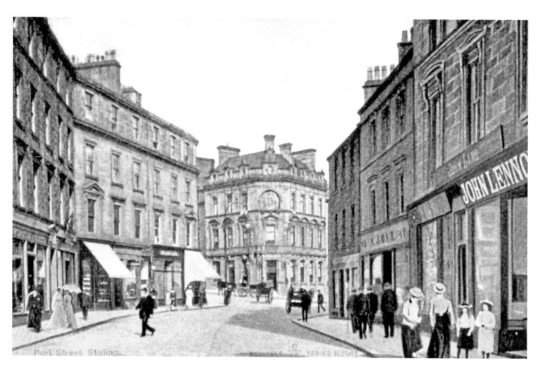

Port Street

Port Street is looking very fashionable in the older image with the Drummond Tract building prominent in the background.

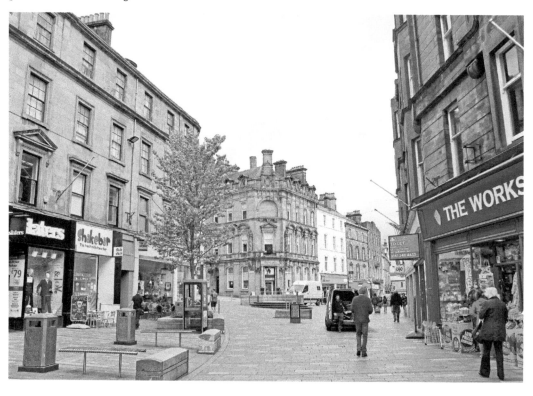

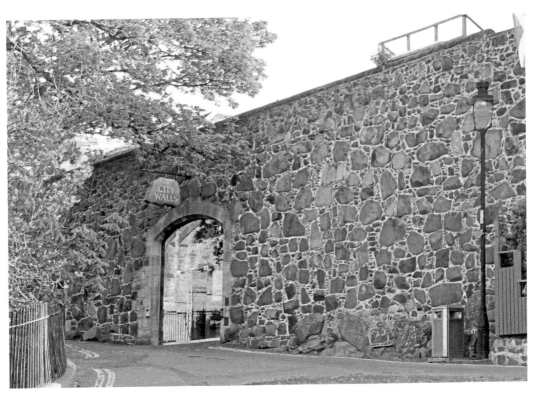

Stirling Town Wall

Despite Stirling's naturally defensive site, an immense town wall was constructed from 1547 during the period of conflict between 1543 and 1551 when Henry VIII was attempting to force an alliance between England and Scotland by the marriage of his son, Edward, to the young Mary Queen of Scots. A period later referred to by Sir Walter Scott as the 'Rough Wooing'. The wall originally ran from the castle to the Barras Yett and onwards to the bastion preserved in the Thistles Shopping Centre.

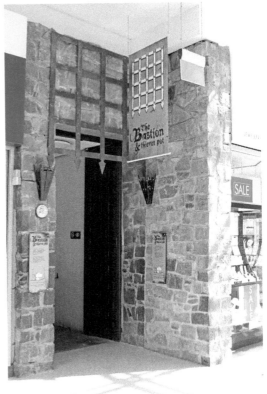

The preserved circular guardroom in the bastion can be accessed down a flight of spiral stairs from the main mall area. It originally protected an angle of the Burgh Wall and includes a sunken 'Thieves Pot' or 'Bottle Dungeon'. Two replica Stirling Heads representing Apollo and a king, possibly James V, are displayed in the bastion.

The remaining sections of the wall in Stirling are the most complete example of this type of defence in Scotland.

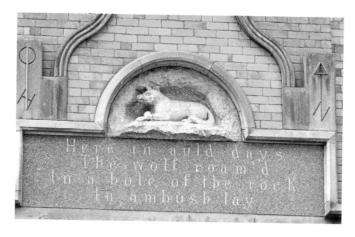

The Wolfcraig Building and the Stirling Wolf, Port Street/Dumbarton Road

The ornate Wolfcraig Building dates from 1897 to 1898 and was built in Welsh red brick as a high-class grocer's shop to a design by John Allan (1847–1922). It was one of the first buildings in the country to be built with a steel frame and is embellished with a sculpture of a wolf and the inscription:

> Here in auld days
> The Wolf roam'd
> In a hole in the rock
> In ambush lay.

The building celebrates the ninth-century legend that Stirling was saved from a Viking invasion when a howling wolf provided an alert of the imminent attack, just in time. Since then, like Rome, the wolf has been adopted as the town's emblem, with it appearing on the coat of arms, burgh seals and buildings throughout the town. There is a degree of irony in this, as the last wolf in Scotland is reputed to have been killed near Stirling in the 1740s.

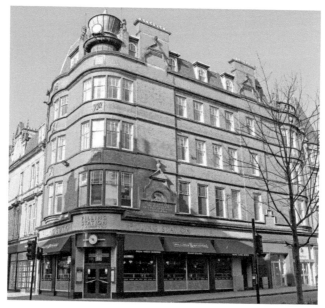

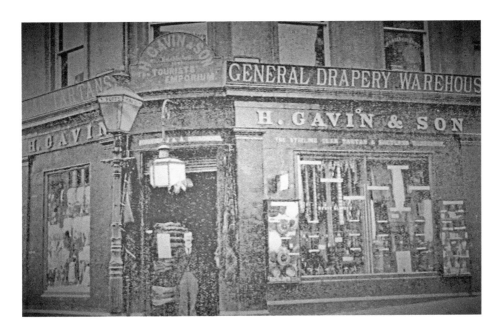

Stirling Shops

Stirling has always been the main market town for the county, with a full range of retail outlets. These two shopfront images are from the 1897 *Merchants' Guide to Stirling*. Hugh Gavin & Sons at No. 1 King Street catered for the tourist market:

> Tourists and visitors to Stirling will find at the Warehouse of Messrs. Hugh Gavin & Son many interesting Souvenirs of Scotland. Clan Tartan, Silk Goods in Handkerchiefs, Belts, Ties, and Sashes, can be had in great profusion while in Woollen Goods they have an extensive variety of Reversible Tartan Travelling Rugs, Scotch Plaids, Shawls, and Dress Materials. The firm have several specialities, one being a beautiful guinea Travelling Rug with reversible Tartans of Bruce and Wallace and Douglas and Bruce – a fitting memento of the heroes of Scotland.

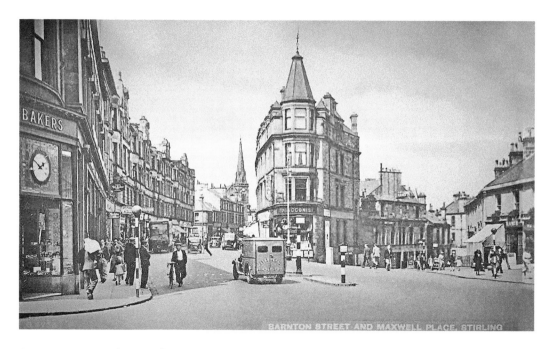

Barnton Street and Maxwell Street

Barnton Street is named for Ramsay of Barnton and Sauchie. The enduring nature of this part of Stirling is reflected in these relatively unchanged views at the junction of Barnton Street and Maxwell Street. The slender spire of Viewfield Church is prominent in the distance on Barnton Street.

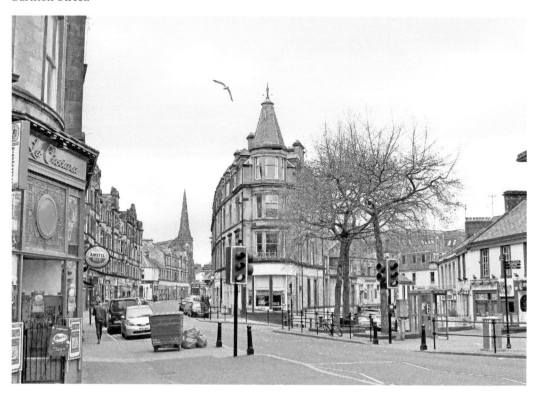

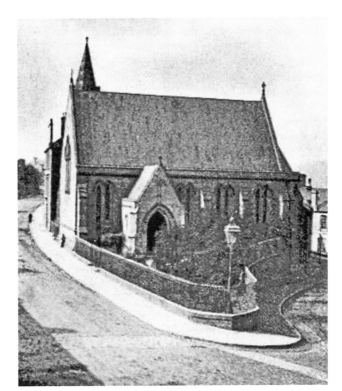

Trinity Episcopal Church, Barnton Street

The Trinity Episcopal Church occupied a site at the junction of Barnton Street and Maxwell Place. It was consecrated in 1845, when the congregation outgrew the existing church on the site, which dated from 1794–95. The site was redeveloped following the church's move to a new building in Albert Place in 1878.

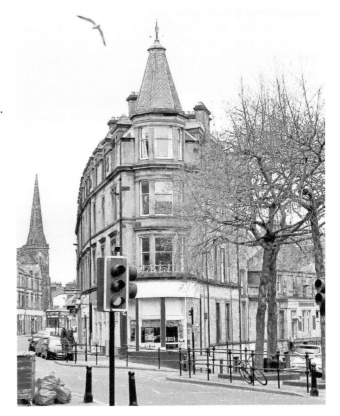

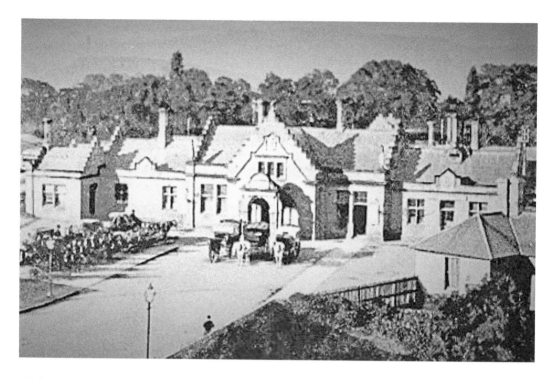

Stirling Railway Station, Goosecroft Road

The railway first came to Stirling in 1848. The present station building, with its picturesque battlements and crow-stepped gables, opened in 1916 following a major rebuild by the Caledonian Railway. It is one of the finest station buildings in Scotland and was designed by the architect James Miller, who is praised for the quality of his Scottish railway stations. The railway made commuting easier and resulted in a substantial expansion of the town.

The road leading down to the station off Murray Place cuts through what was, in ancient times, the burial grounds of the Dominican Friars.

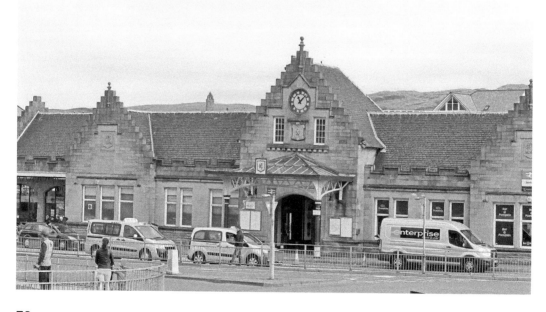

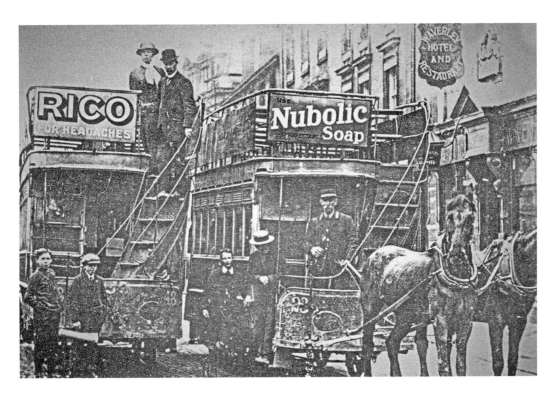

Stirling Trams

The Stirling and Bridge of Allan Tramway opened on 27 July 1874 with a single line between Port Street and Henderson Street in Bridge of Allan. This was extended on 29 January 1898 with a service from King Street to St Ninians. There were a number of failed attempts to electrify and expand the service, and Stirling's tram service ended on 20 May 1920.

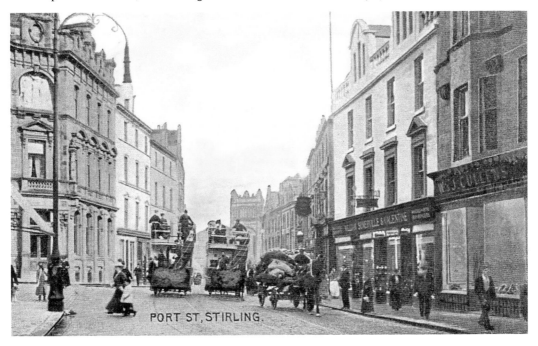

PORT ST, STIRLING.

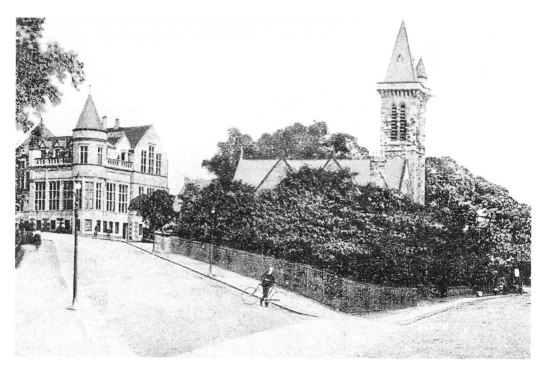

Stirling Library and Allan Park South Church
Almost unchanged views of the Allan Park South Church and Stirling Library in these two images separated by over 100 years. The church was built on the north side of Albert Place as the United Presbyterian Church in 1865–67. The library dates from 1904.

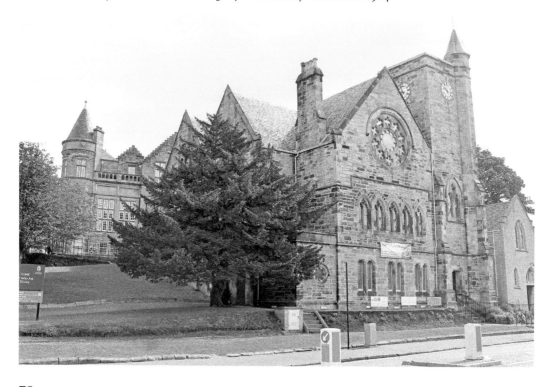

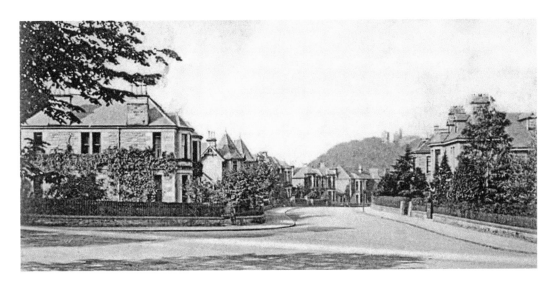

Glebe Crescent

In the nineteenth century, there was a significant development of pleasant suburban villas around Stirling. Glebe Crescent is a good example of these substantial mid- to late-Victorian stone villas. The spires of the Church of the Holy Rude and county jail are prominent in the background. The ornamental iron railings at the front of the houses in the earlier image would have been removed for the war effort in the 1940s. Railings and gates were removed throughout the country during the Second World War following a direction by Lord Beaverbrook, the wartime Minister of Supply. There is some debate about what happened to them after they were removed. It is claimed that the metal was unsuitable for reprocessing and that they were dumped at sea. There are stories that there was so much offloaded in parts of the Thames that the vast quantity of iron disrupted ships' compasses. It is also claimed that they were used as ballast in ships, with many houses in African seaports being festooned with fine Georgian railings salvaged in the destination ports. The removal of so much ornamental cast iron was a great architectural loss. However, even if they never became guns and tanks, it was seen as a morale-boosting exercise.

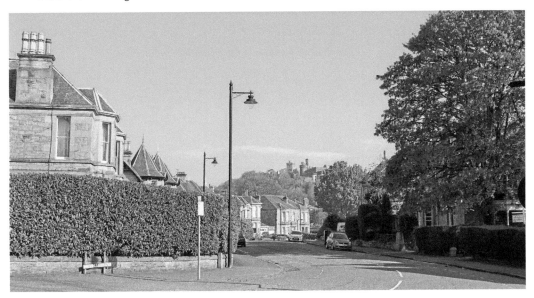

Greetings from Stirling

The historic and architectural heritage of Stirling has long been an attraction for visitors and continues to play a major role in Stirling's tourist economy. This was particularly boosted with the building of the National Wallace Monument and in the 1920s and 1930s Stirling featured on railway posters advertising the delights of visiting 'Bonnie Scotland'.

These two early postcards illustrate some of the area's main tourist sites and attractions.

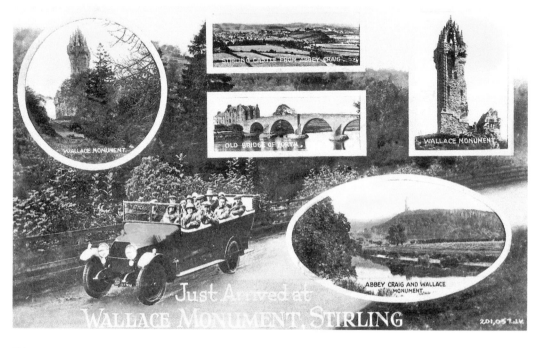

The Royal Hotel.

THE LEADING FAMILY HOTEL in Stirling, having been thoroughly renovated and added to by erecting new Billiard Room, with Bathrooms and Lavatories, on the most approved sanitary system. Parties visiting Stirling will find at the Royal all the Comforts of a home, combined with Moderate Charges.

The Coaching
And Posting Department

Is Complete with Steady and Experienced Drivers.

ALL ORDERS BY WIRE OR TELEPHONE PROMPTLY ATTENDED TO

JOHN CURRIE,
PROPRIETOR AND MANAGER.

Telephone No. 314.

Royal Hotel, Murray Place

Stirling's popularity as a tourist destination resulted in a demand for hotel accommodation and the 1897 *Merchants' Guide to Stirling* lists around fifteen hotels in and around the town.

The Royal Hotel was on the corner of Barnton Place and Friars Wynd.

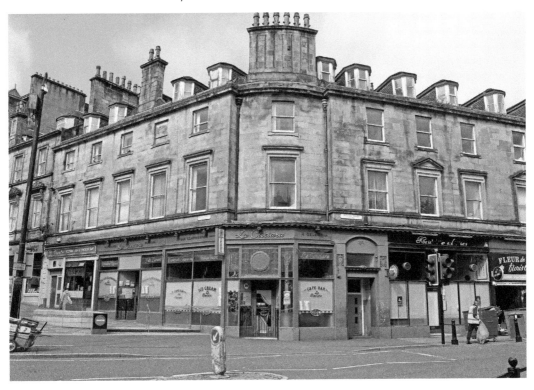

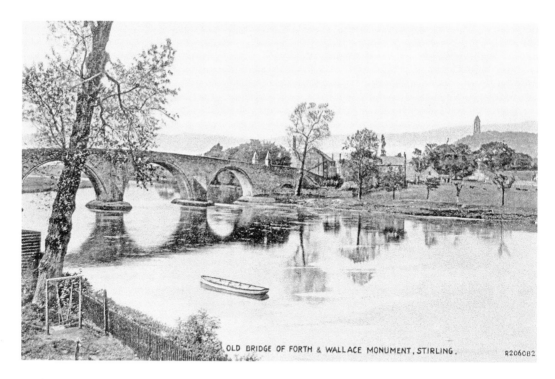

OLD BRIDGE OF FORTH & WALLACE MONUMENT, STIRLING.

R206082

Stirling Old Bridge

Stirling owes much of its early prominence and prosperity to the beautiful and picturesque Stirling Old Bridge, which for 400 years was the only roadway over the River Forth and the most strategically important river crossing in Scotland. The bridge was built in the early part of the fifteenth century and its construction is ascribed to Robert Duke of Albany, Earl of Fife and Menteith. The bridge, protected by the castle, is the main reason for Stirling's existence. A bridge, probably in timber, existed at least as early as the thirteenth century.

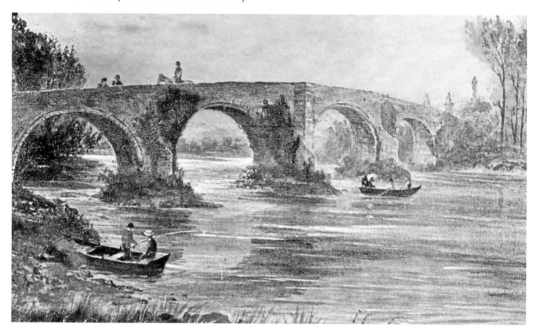

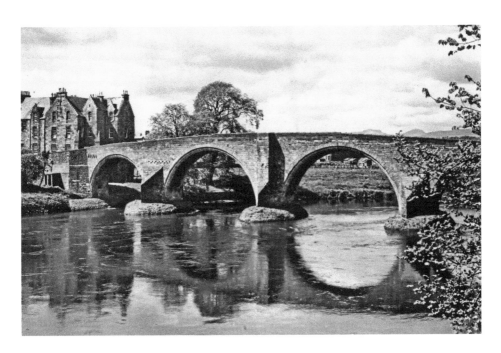

Stirling Old Bridge

The roadway of the bridge is supported on four semi-circular arches; none of which has the same width of span. The bridge previously had massive towers with arched gateways at each end. The south archway was removed when the arch of the bridge was cut in 1745 during the Jacobite rebellion, preventing the Highlanders from crossing into Stirling, and the north archway was taken down in 1749.

The bridge was closed to vehicles in 1834 and the tenement on the north side of the bridge, which can be seen in the earlier image, was demolished in the 1960s.

The bridge is downstream from the earlier wooden bridge that spanned the River Forth and was the site of the Battle of Stirling Bridge.

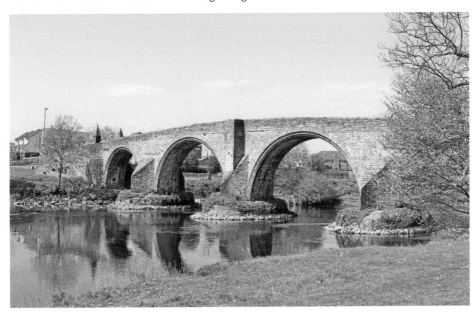

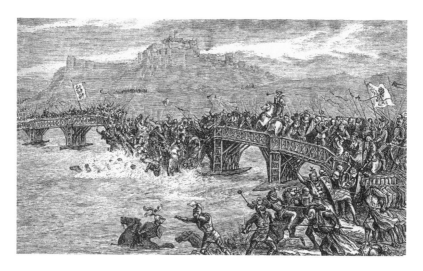

Battle of Stirling Bridge

The old wooden bridge at Stirling, which was central to the Battle of Stirling Bridge on 11 September 1297, was located around 180 yards upstream from Stirling Old Bridge. The battle was a famous victory for Scotland's national hero William Wallace during the First War of Scottish Independence. The key to the Scottish victory was the tightly packed schiltrons (circular formations of men with long spears) which proved impenetrable to the English knights:

> When news arrived that the Earl of Surrey was pressing forward at the head of a large English army, Wallace immediately advanced to the River Forth, and took up his position along the loop of the River Forth in front of the Abbey Craig, where the massive tower reared to his memory now stands. Terms offered by the English leaders having been rejected, they advanced to the attack. A proposal that a portion of the army should cross by the neighbouring ford was not acted on, and the whole line began to advance by the bridge, which was so narrow that only two persons could pass abreast. When about half of the English force had crossed, a body of spearmen, sent by Wallace for the purpose, dashing suddenly forward, gained and took possession of the end of the bridge, and Surrey and the rest of his forces had to stand helplessly by and see their comrades who had crossed attacked and routed by the Scottish army
>
> Ordnance Gazetteer of Scotland (1882)

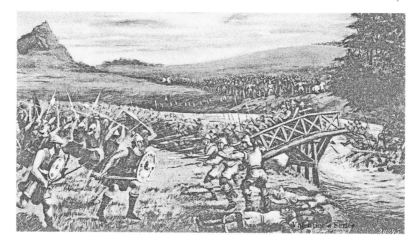

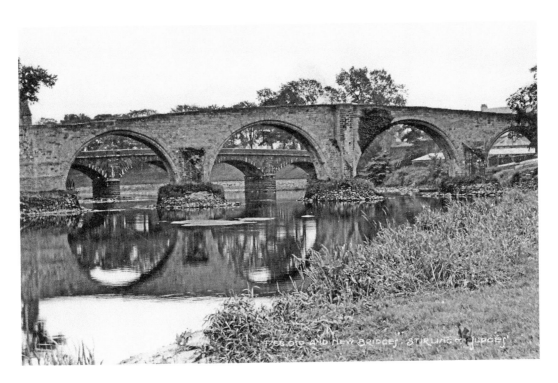

Stirling New Bridge

Stirling New Bridge is just downstream from the Old Bridge. It was opened in 1833 and was designed by Robert Stevenson (1772–1850), one of the Scotland's most eminent civil engineers, renowned designer of lighthouses and the grandfather of Robert Louis Stevenson. An alternative design by Thomas Telford was rejected.

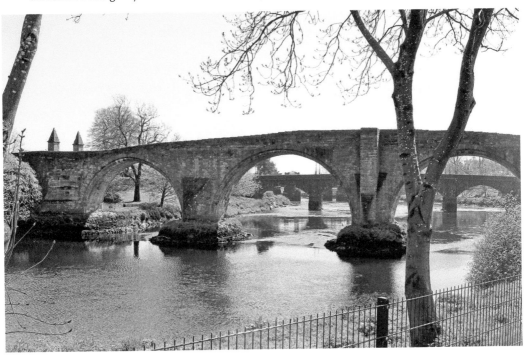

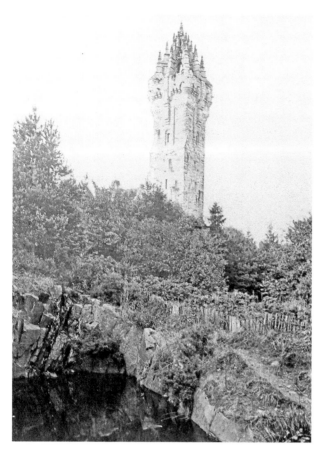

National Wallace Monument, Abbey Craig

It took a long time for a fitting memorial to be built to Wallace, but when this great landmark was built its grandeur more than compensated for the delay. From the 1820s onwards, proposals had been made for different sites in both Edinburgh and Glasgow for a monument to Wallace – in 1859, the site at Abbey Craig was agreed. A fundraising campaign was established and a national competition was launched for a suitable design. John T. Rochead's (1814–78) soaring Scottish Baronial tower, surmounted by an imperial crown, was the winning entry.

The foundation stone was laid by the Duke of Athole, Grand Master Mason, among much ceremony and in front of a crowd estimated at 80,000 on 24 June 1861. It opened on 11 September 1869, the 572nd anniversary of Wallace's great victory at Stirling Bridge.

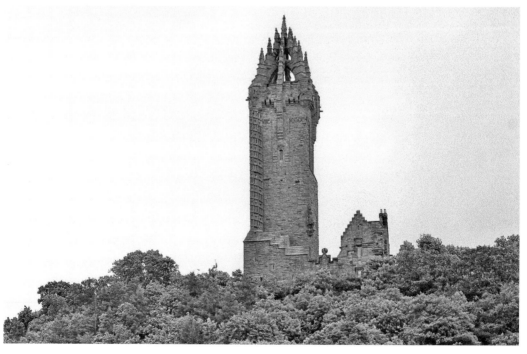

National Wallace Monument, Abbey Craig

In our estimation it would be impossible to find a situation in all respects more suited for a national monument, or better adapted for a memorial cairn to the national hero. Abbey Craig is geographically in the centre of Scotland; it is likewise the centre of the Scottish battle-ground for civil and religious liberty. It overlooks the field of Stirling Bridge, where Wallace obtained his greatest victory; and the monument will surmount the spot where he is believed to have stood while surveying the legions of England crossing the bridge, in their path to destruction

Revd Dr Rogers (1861)

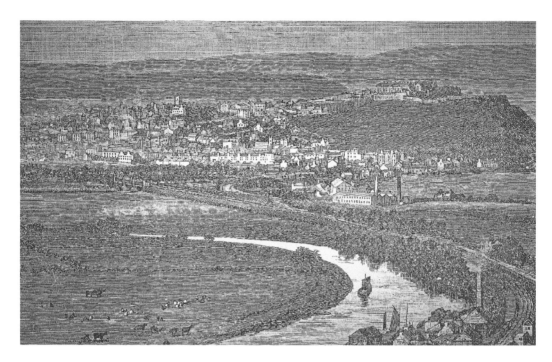

View from Abbey Craig

Here we feel elevated, as if by enchantment, in the midst of a fairy scene, a panorama of the most ennobling character. Around is a level plain, watered by the silvery courses of the River Forth and guarded at almost every point by stupendous mountains. For miles on every side, everything is picturesque, beautiful, or sublime, there being not one single feature to mar the loveliness of the landscape or detract from the poetry of the scene.

Revd Dr Rogers, *A Week at Bridge of Allan* (1853)

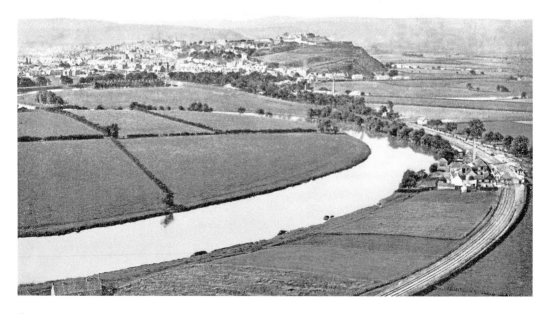

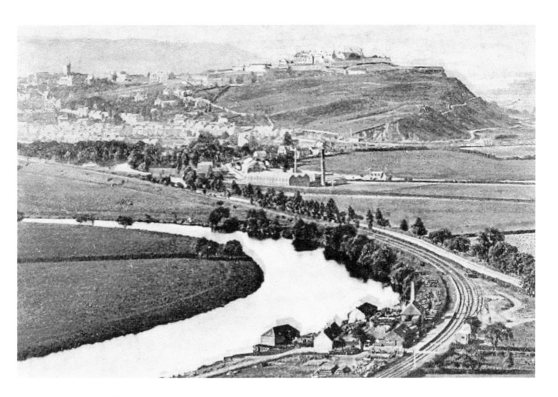

View from Abbey Craig

The spectacular panorama from Abbey Craig towards Stirling with the 'silvery Forth reposing, serpent like, in the centre of the plain'.

The fertile soil in the meanders or links of the River Forth at Stirling gave rise to the old rhyme: 'A crook o' the Forth is worth an Earldom o' the north'.

Causewayhead railway station can be seen in the right foreground of the earlier image. It was a stop on the Stirling and Dunfermline Railway; the station opened on 1 July 1852 was closed on 1 January 1917, reopened 2 June 1919 and was finally closed 4 July 1955.

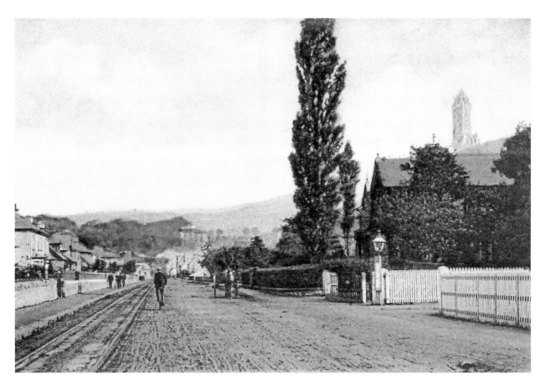

Causewayhead

Causewayhead developed around the junction which links Stirling with Bridge of Allan, the Hillfoots and Alloa. The name relates to its location at the head of a mile-long causeway that crossed the marsh to the north of Stirling Old Bridge.

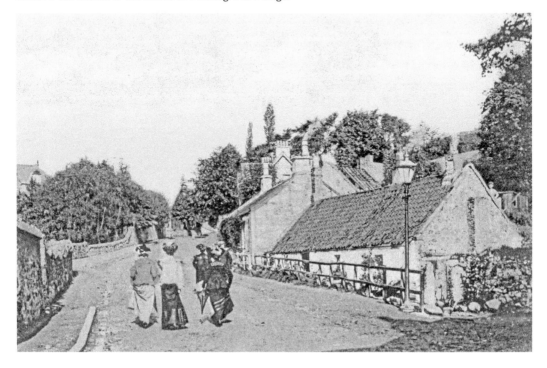

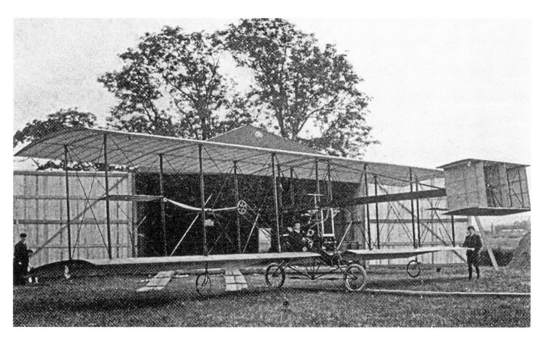

Barnwell Brothers

The monument depicting a plane on a stone cairn at the Causewayhead roundabout was unveiled in April 2005 to commemorate the achievements of Stirling's very own aviation pioneers, Harold (1878–1917) and Frank Barnwell (1880–1938).

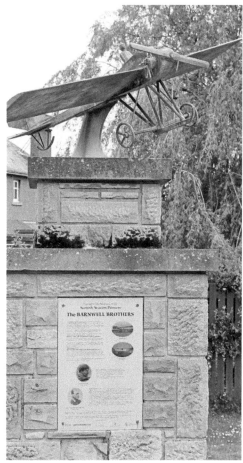

The Barnwell brothers opened the Grampian Motor and Engineering Co. in 1906, near the site of the monument in Causewayhead. They put together their first attempt at a plane in 1908 although the motorbike engine they used was not powerful enough for a take-off. However, on 28 July 1909 their biplane, piloted by Harold and powered by a car engine, travelled 80 yards (75 metres) at an altitude of around 4 metres over a field at Causewayhead before it crashed. This flight is recognised as the first powered flight in Scotland, some six years after the historic flight by the Wright Brothers. In January 1911, a monoplane designed by the brothers was the first plane to fly for more than a mile in Scotland.

Harold Barnwell went on to become the chief test pilot with Vickers and died on 25 August 1917, while testing a prototype plane. Frank Barnwell had a career as a prominent aircraft designer and was killed in an aircraft crash in 1938. The site of their factory has recently been redeveloped for housing.

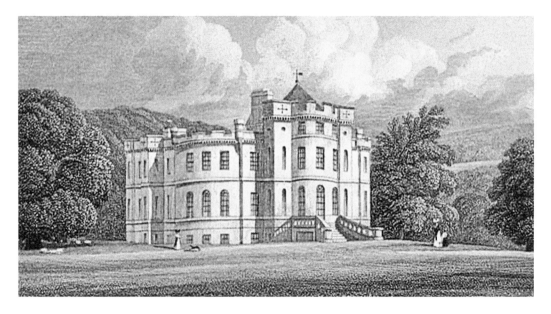

Airthrey Castle

Records of the Airthrey Estate date back to the twelfth century; over the centuries it has passed through the ownership of a number of noble families. In 1759, the estate was sold to the Haldane family who commissioned the landscaping of the grounds by Thomas White and a new house by Robert Adam which, despite later additions, still forms the core of the present building.

The castle functioned as a maternity hospital during the Second World War and continued in this use until 1969, allowing a number of locals of a certain age to quite correctly claim that they were born in a castle. The Airthrey Estate now forms the campus of the University of Stirling.

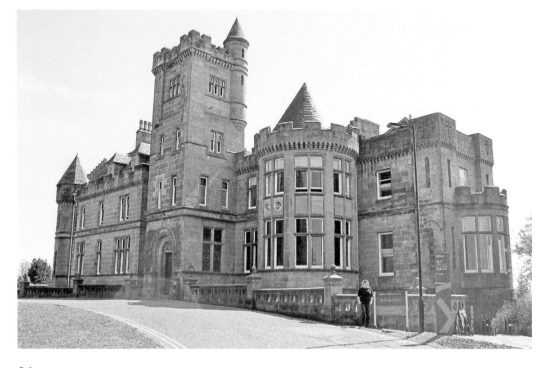

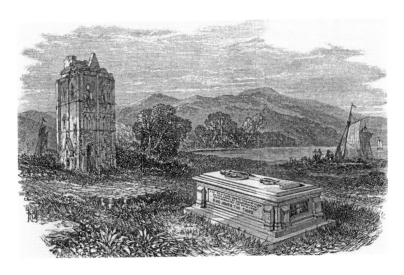

Cambuskenneth Abbey

Cambuskenneth Abbey was established by David I in 1147 as a dedication to the Virgin Mary. It was originally known as the Abbey of St Mary or the Abbey of Stirling. It was one of the wealthiest and most important abbeys in Scotland due to its royal connections and proximity to Stirling Castle. At its height, the abbey comprised an extensive complex of buildings.

The abbey's closeness to Stirling Castle put it in the way of attack during the Wars of Independence; in 1383, it was largely destroyed by the army of Richard III and it was rebuilt during the early 1400s. It was also the scene of a number of significant historic events: in 1314, Robert I held a Parliament at the abbey following the Battle of Bannockburn.

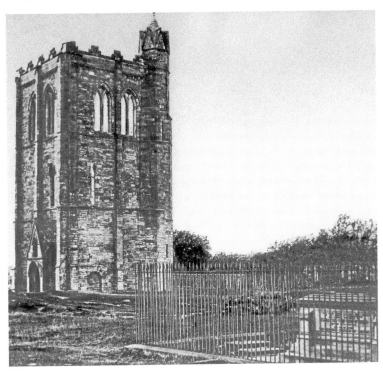

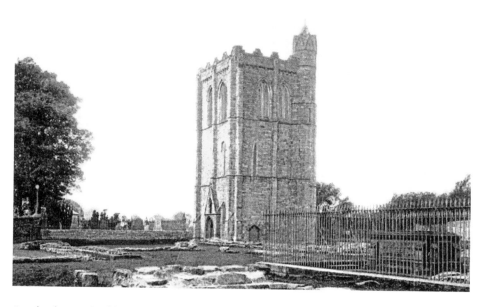

Cambuskenneth Abbey

The abbey was abandoned in 1559 during the Scottish Reformation with stone removed for building work in the town – including Mar's Wark.

The abbey is reduced to its foundations with the exception of the dramatic three-storey square bell tower, which dates from 1300 and is considered to be the finest surviving medieval bell tower in Scotland.

The elaborate tomb on the site marks the last resting place of James III who was murdered near Bannockburn after fleeing the Battle of Sauchieburn on 11 June 1488. He was interred in front of the high altar of the abbey church, alongside his Queen, Margaret of Denmark, who died in 1486. The tomb was paid for by Queen Victoria, following the discovery of two coffins which were presumed to be those of the royal couple in 1865.

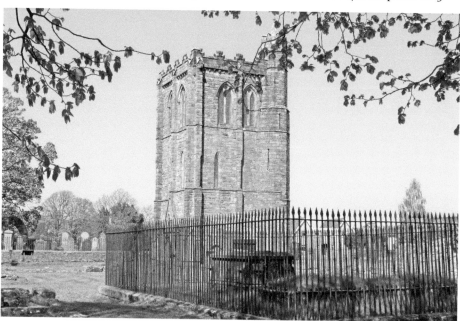

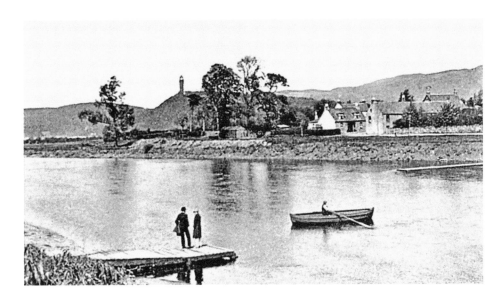

Cambuskenneth Ferry

The ferry boat connection between Stirling and Cambuskenneth dates back for centuries. The ferry avoided the much longer journey by way of Causewayhead and Stirling Bridge.

The patrons of Cowane's Hospital ran the ferry, between 1709 and 1935, with a local man appointed as ferryman and provided with a house at the site of the ferry. The ferryman was expected to be on duty between 5 a.m. and 10.30 p.m., but was allowed to charge extra for crossings outside the regular hours. The 1919 rules specified that a ticket costing a penny was to be issued for each payment and that no coal was to be carried.

The loop of the River Forth at Cambuskenneth was particularly fertile and the area was famed for its fruit production. The ferry was much in demand during the Berry Fair when Stirling residents would make the crossing to buy the produce.

The operation of the ferry on the Sabbath outraged Peter Drummond (1799–1877), and he started a leaflet campaign against the blasphemous act in 1848. This led to Drummond establishing the Stirling Tract Enterprise, a major religious publishing business.

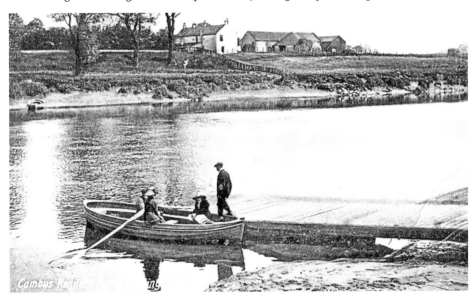

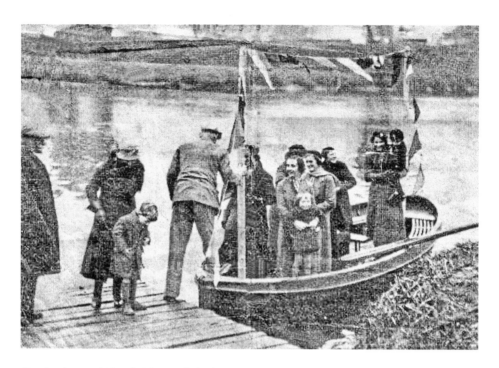

Cambuskenneth Footbridge and the Last Ferry Boat

Proposals to replace the Cambuskenneth Ferry with a bridge were discussed from the early part of the nineteenth century and rumbled on into the early twentieth century. In 1930, Cowane's Hospital gave notice of the intention to discontinue the ferry service, since it was not obliged to supply one, and derived no profit from it. There were also complaints that the ferry was unsafe and inconvenient. This spurred on the authorities and the opening of the new footbridge on the 23 October 1935 marked the end of the ferry. The last boatman was Thomas Dow, who had succeeded his father, also Thomas, in the job in August 1933.

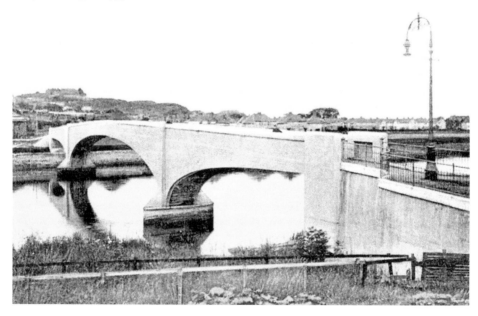

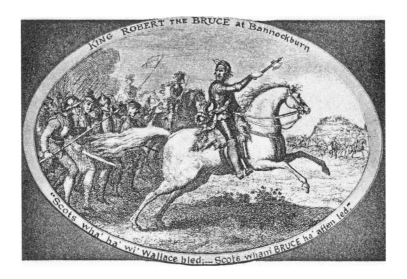

Battle of Bannockburn

The Battle of Bannockburn on 23 and 24 June 1314 was a famous victory for the Scots against the vastly superior invading army of Edward II. The victory secured Robert the Bruce's reputation as one of the great heroes of Scottish history and Scotland's future as an independent nation.

> Bruce and de Bohun, were fightin' for the croon
> Bruce taen his battle-axe and knocked de Bohun doon.

King Robert was ill mounted, carrying a battle-axe, and, on his bassinet-helmet, wearing, for distinction, a crown. Thus externally distinguished, he rode before the lines, regulating their order, when an English knight, who was ranked among the bravest in Edward's army, Sir Henry de Boun, came galloping furiously up to him, to engage him in single combat, expecting, by this act of chivalry, to end the contest and gain immortal fame. But the enterprising champion, having missed his blow, was instantly struck dead by the king, the handle of whose axe was broken with the violence of the shock.

<div align="right">

William Nimmo, *History of Stirlingshire* (1880)

</div>

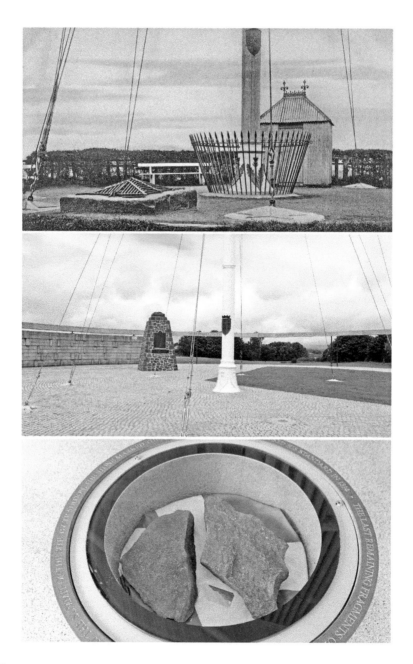

The Borestone

Tradition has it that the Scottish Standard at Bannockburn was raised on a circular millstone, which is known as the Borestone. It became an emblem of national pride for many Scots and a target for early memento hunters who chipped off parts of the stone as keepsakes. The stone was later protected by an iron grille and in 2014 the remaining two pieces were moved inside the new visitor centre. The original site of the Borestone is marked by a bronze B-shaped plaque.

The flagpole was erected in 1870 by the Dumbarton Loyal Dixon Lodge of the Independent Order of Odd fellows. The rotunda that surrounds the cairn and flagpole includes lines from Kathleen Jamie's poem, *Here Lies Our Land*.

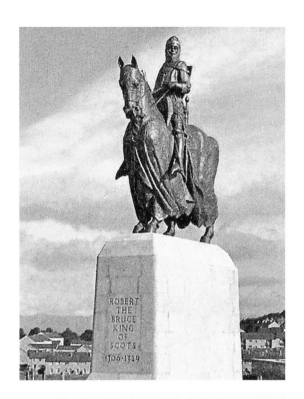

Bruce Statue, Bannockburn
The bronze equestrian statue of Bruce at Bannockburn, by the sculptor Charles d'Orville Pilkington Jackson, was unveiled in 1964 by the Queen on the 650th anniversary of the Battle of Bannockburn.

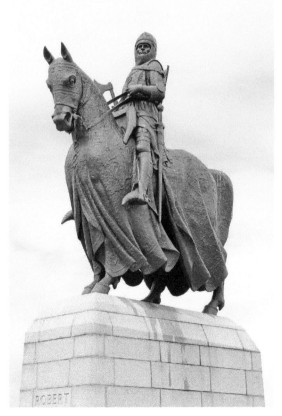

93

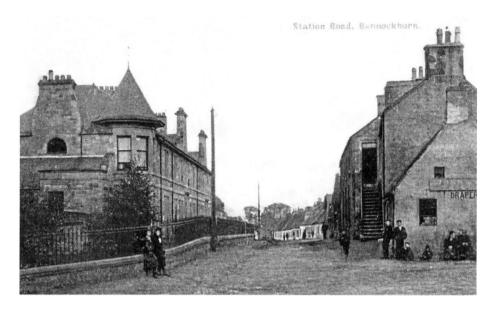

Bannockburn, Station Road

Bannockburn, immediately south of Stirling, takes its name from the Bannock (White) Burn which runs through the town. The town with its access to water power, nearby grazing for sheep and proximity to the emergent markets in central Scotland developed from the mid-eighteenth century from a small ancient settlement to a bustling centre for tartan and carpet weaving. The town continued to thrive with the opening of the Bannockburn Colliery at Cowie in the 1890s. Bannockburn Station opened in 1848 as a stop on the Scottish Central Railway, and closed in 1950.

The centre of the town has lost much of its historic architecture due to mass redevelopment in the second half of the twentieth century.

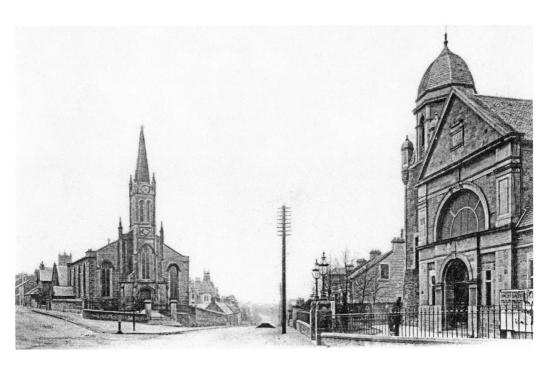

Bannockburn, Allan Church and Town Hall

The Allan Church, Main Street and New Road dates from 1837 to 1838. It takes its name from the Revd James Allan who was ordained as the minister in 1888 and who was an influential figure in the town.

Bannockburn Town Hall with its distinctive domed turret opened on 25 May 1888. It was demolished in the mid-1970s and is now the site of the Memorial Park. The original Bannockburn War Memorial, depicting a kilted soldier on a granite plinth, was unveiled on 2 October 1921 to commemorate the ninety-four men of Stirling who fell in the First World War. After the end of the Second World War, the memorial was replaced by a granite obelisk.

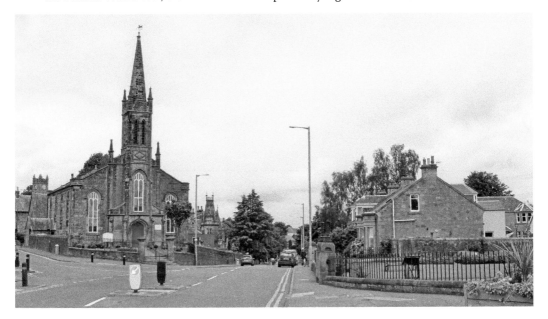

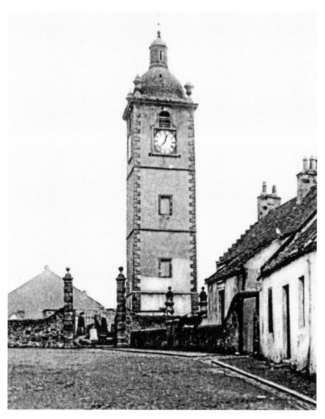

St Ninians Tower, Kirk Wynd

St Ninians is an ancient village, approximately one mile south of the centre of Stirling. It developed around the kirk, which is first recorded in the mid-twelfth century.

The early church, which had fallen into disrepair, was extensively altered and rebuilt in the early eighteenth century. However, it was mainly destroyed in 1746, when it was being used by the Jacobite army as a gunpowder magazine. Only the tower, which dates from 1734, and part of the earlier chancel survived the blast. A new parish church was built in 1751 to the east.

St Ninians prospered in the eighteenth and nineteenth centuries based on local weaving, mining and nail making. After the Second World War, large-scale demolition and road building resulted in the loss of many historic buildings in the village.

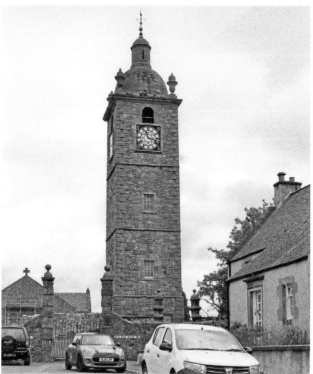